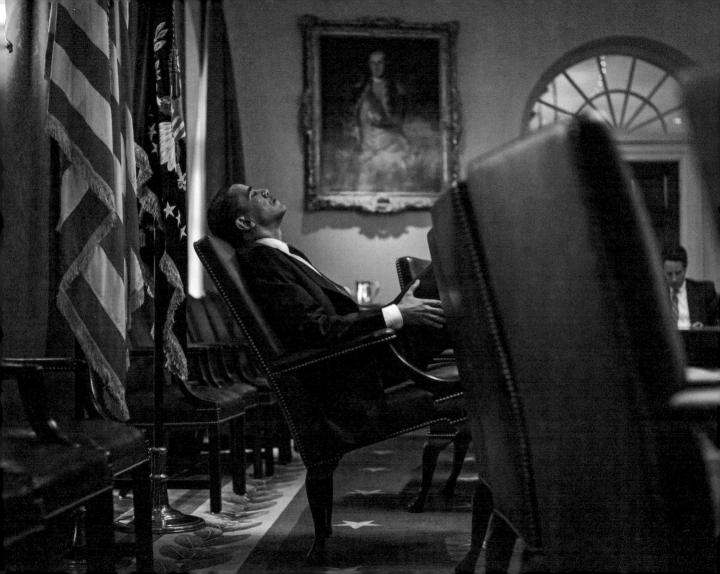

HOPE, NEVER FEAR

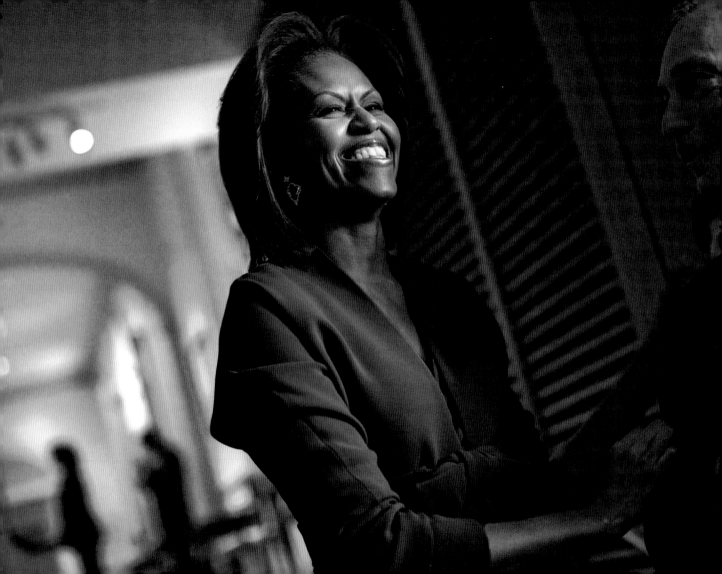

HOPE, NEVER FEAR

A PERSONAL PORTRAIT OF THE OBAMAS

Callie Shell

CHRONICLE BOOKS
SAN FRANCISCO

in association with

Blackwell&Ruth.

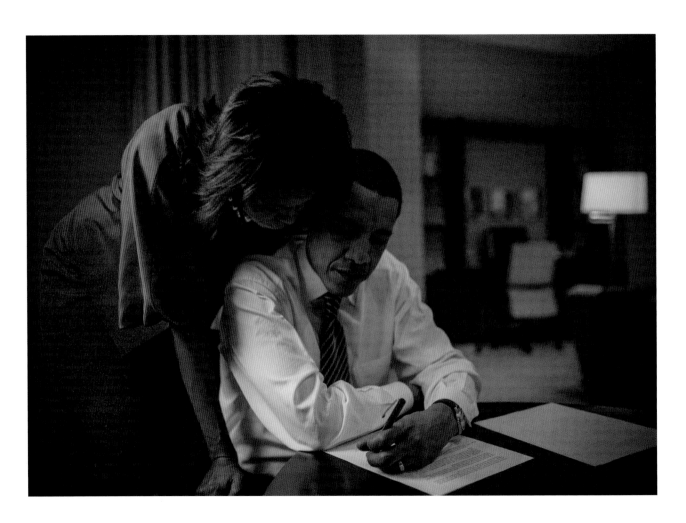

For . . .

My compass and world—Vince and Hunter—priceless treasures who complete me.

My mother and father—who made me feel smart and strong; who taught me that anything is possible; and who encouraged me to take a leap, go against the crowd, and choose my own path.

The Obamas—for trusting me when their lives were changing and turning upside down.

Every person who lacks or has lost faith in themselves—the words in this book are here to lift you up and inspire; the images to prove that you can achieve anything, if you have hope and believe.

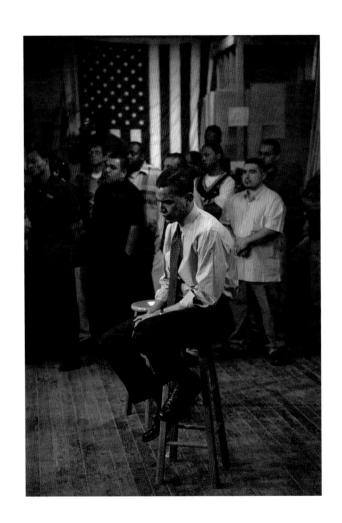

**Greater West Town Training
Center, Chicago, IL, April 4, 2004**

Illinois State Senator Barack
Obama after introducing
presidential candidate Senator
John Kerry at a rally.

This book isn't a love fest for the Obamas. It isn't meant to make us miss them more or deepen what divides us. It is, instead, my personal portrait of a journey that changed us all for the better. It is a reminder of the difference this family made when our country needed change and something to believe in. It is to show, through my images and their words, where they came from and what they did. And in showing that, to say it is now our time to pick up where they left off and carry on what they started. With hope, not fear.

I first met Barack Obama at a rally for Senator John Kerry in Chicago on April 4, 2004. I was there to photograph Kerry for *Time* magazine; he was there to introduce Kerry at the rally.

I liked him instantly. He was charismatic, funny, and engaging. I watched him hang out in the back hallway while Kerry took interviews. He said hello to everyone—not just Kerry's staff, but the janitor, the building staff, and the union workers. He was personable, with a genuine smile. Eventually he made his way over to me, and said, "What do you do?" We started talking about our kids, his youngest being the

same age as my son, Hunter. We joked that we were both tall and had big ears, and that we had both married up in life; that we had great spouses. I thought at the time that I could see myself being friends with him.

When he went onto the floor, I was surprised at the enthusiastic response. People were so excited to see him that the applause he received was louder than it was for Kerry. I took a lot of photographs of him that day, and when my editor at *Time* joked that I must be getting bored photographing Kerry, I told her that I thought Obama might run for president one day. A few months later, he gave the keynote address at the Democratic National Convention in Boston, and suddenly everyone was talking about him. My editor said, "So this is the guy, the one you've been talking about!" Later that year he won the election for U.S. Senate in Illinois, and I asked *Time* if I could photograph his freshman year as a senator. That was the start of my journey with the Obamas.

I had not planned to spend my career photographing politicians. I had no interest in politics growing up. I developed a love of photography in high school, taking pictures of my friends, and after college I

worked for various newspapers as a photojournalist. I realized I wanted to give back and make a difference, and I felt photography was an effective medium to do this. It could educate people and show them what was happening in the world.

After meeting my husband Vince, we moved to Washington, DC, while I worked for the administration of President Bill Clinton and Vice President Al Gore. It was initially only meant to be for one week, which turned into one hundred days, which turned into eight years. And that was my first introduction to political photography.

It was an eye-opening experience. It made me realize how hard people at the White House work, and how much they actually care. There are a large number of people working there, dedicating their lives to making government work for those who need its help most. It was inspiring. And eventually, it led me to the Obamas.

I first met Michelle at her home in Hyde Park, a Chicago neighborhood, as she sat at her kitchen table, balancing her checkbook, checking her Blackberry, and talking with her daughters, Sasha and Malia.

I was there on assignment, spending a few days with Obama for *Time*. She was exactly what he said she was—strong, gorgeous, funny, and wise beyond her years. She told me, "We are big on hugs in this family," and welcomed me into her home without question. She warned me that my profile of her husband was going to "make his head bigger than it already is," adding fondly: "Whatever you do, just don't put him on the cover." We did.

I was simultaneously awed by this amazing woman, who seemed to balance her career and family so easily, and frightened by the reality of what a presidential campaign would mean for the Obamas should her husband decide to run. There was no doubt in my mind that she would be an incredible First Lady, or that he would be an extraordinary president. But I felt a gnawing sense of dread—here they were, both so down to earth, and completely obsessed with their kids. They had what seemed like the perfect family life.

That same day, after the family served themselves cereal for breakfast, I took a picture of Obama washing the dishes with the girls (p. 63).

Hyde Park, Chicago, IL, October 2, 2006

On the front steps of their home. (Malia is eight, Sasha is five.)

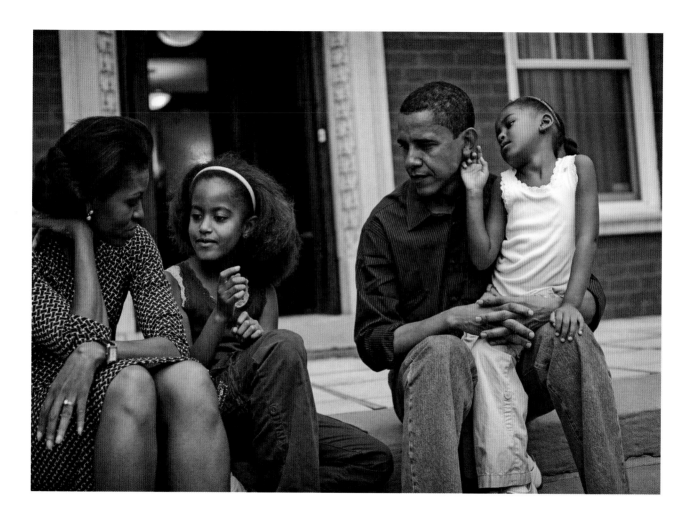

I couldn't help but feel that this life would soon be gone. There would be no more washing dishes, no more balancing the checkbook at the kitchen table, no more dropping the kids at school—all simple things that we perhaps take for granted, until they're gone.

After eight years with Vice President Gore, I felt an innate desire to swoop in and stop this family before the madness of a presidential campaign could begin.

The whirlwind built slowly. We spent time in those first few calm months in vans driving across Illinois. There was no security detail, no entourage, no frenzied media. It was low-key and relaxed—just Obama laying the groundwork. The image I took of him in October 2006, shaking hands with a couple through their car window (p. 105) epitomizes the simple, honest, grassroots campaigning of those early days. The couple had rolled down the window and said, "Aren't you that guy? You're Barack Obama, the senator, right?" He loved talking to people and hearing what they had to say. He was naturally friendly and outgoing, and, with no staff or Secret Service to restrict him, he immediately introduced himself to the couple and started up a conversation.

I got the impression that this ability to greet people and talk comfortably with anyone was something he cared deeply about. Later that same day, on a phone call with staff in Washington, DC, he emphasized that the workers out meeting the public needed to be people who loved to engage with others, and who really cared. Some people would only ever get to meet his staff, so he wanted them to be a reflection of him; of his empathy, and his ability to listen and build a rapport. It didn't need to be about politics—he had a genuine interest in what people thought, and he enjoyed simple, everyday conversations with strangers. He had a way of making people feel at ease, and making them feel that their views were important. He looked people in the eye when he spoke to them. On his way back from buying lunch one day, he stopped to talk to a woman at a gas station (p. 152). I think small one-on-one conversations helped him feel grounded and connected to real people.

As the months went by, things accelerated. Obama's popularity grew; and in February 2007 he announced he was running for the presidency in 2008. The campaigning intensified, and the crowds grew. It was extraordinary for a new candidate to pull in such big

crowds at rallies. People were intrigued by this young, energetic, and charismatic leader. He acknowledged the people who came out to see him, working his way through the crowds after speaking, shaking people's hands, and thanking them (p. 194). People began to stop him on the streets. The difference now, compared with a year earlier when he had time to shake a couple's hands through their car window, was stark.

Unlike some politicians I have photographed in the past, I found it easy to take pictures of him on his own, even as the campaign progressed. He let his staff do their jobs and didn't want them fussing over him. He seemed comfortable in front of my camera, and had a calm, relaxed demeanor in general. I made sure he knew he could tell me to stop taking photographs at any time. In the early days of the campaign, when we were still traveling in a van, I could see that he was getting tired, so I asked him if I could take a picture should he fall asleep. He said he didn't care, but that Michelle told him when he falls asleep his mouth drops open—so if his mouth dropped open, there were to be no more pictures. Thus, when a year and a half later, he fell asleep on his campaign bus, I knew it was okay to document the moment.

Campaign bus, Mt. Pleasant to Fairfield, IA, November 8, 2007

Obama reads the paper during a morning briefing as his campaign bus travels through Iowa.

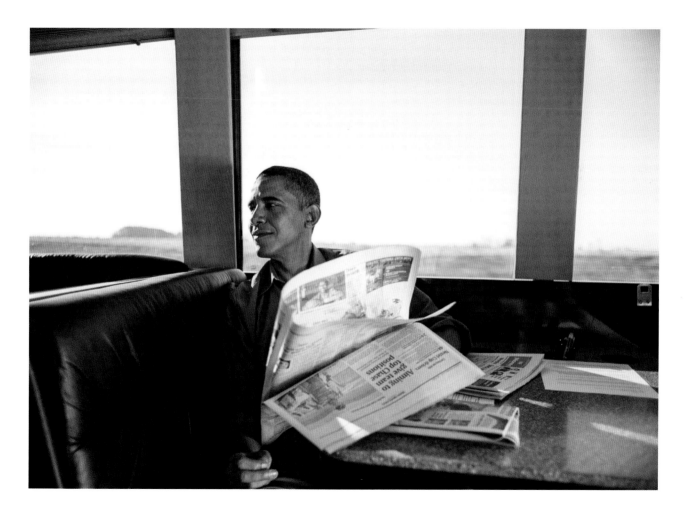

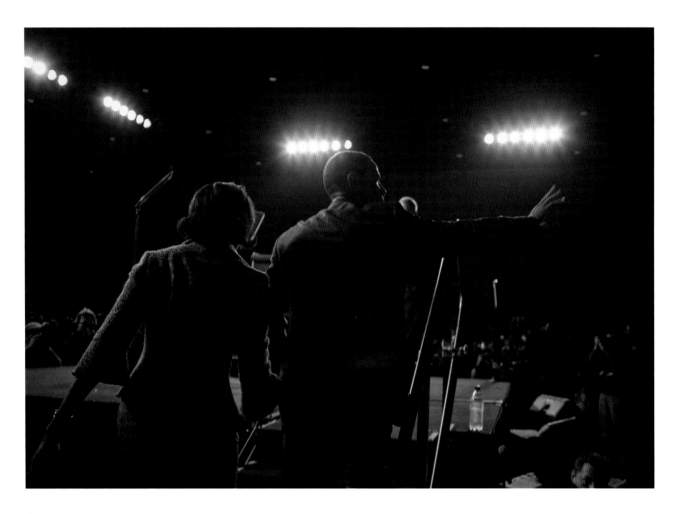

A few seconds after I captured him drifting off to sleep (p. 130), the mouth dropped open—and I stopped taking pictures. For me, this photograph represents how lonely a campaign can become, and what a person gives up. You are sleeping on a bus in between late-night rallies, away from your home and family.

As the campaign progressed, time on the road increased. Days were long and exhausting. Obama was away from his family for long stretches at a time, and he seemed to hate it. He loved his daughters, and made time to Skype with them every night. Missing them, I think he enjoyed interacting with kids on the campaign trail or having breakfast with a young boy at a diner in Scranton, Pennsylvania (p. 72). He had no trouble connecting with children.

It was also clear that he missed Michelle deeply. They complemented each other; she energized and grounded him, bringing a lightness and a joy to what were often stressful, high-pressure days. He was visibly excited about seeing her and would be in great moods on the days he knew they would be meeting up at a rally.

Convention Center, Columbia, SC, January 26, 2008

The Obamas take the stage to greet supporters after winning the South Carolina primary. It was the first primary in a southern state, and a state expected to vote for Hillary Clinton.

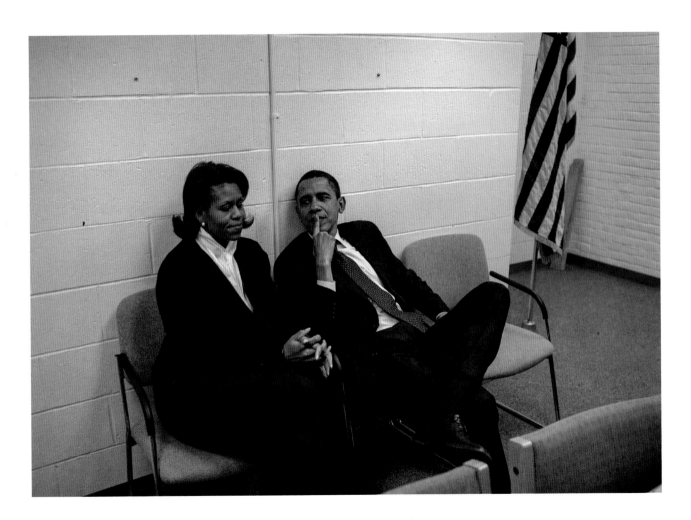

In the first few months of 2008, the Obamas' private time seemed to consist of a few crossover moments in back hallways before rallies. When I captured them sharing a rare moment of quiet time aboard the campaign bus, I could tell they loved being together, even briefly (p. 106). This image is especially important to me; I felt I had reached a point of trust with both of them, especially Michelle.

After Obama won the Democratic presidential nomination (p. 99), life grew even more frenzied. Crowds of 50,000 to 100,000 people turned out to his rallies, and he quickly moved from the underdog to the favorite. His running mate, Delaware Senator Joe Biden, couldn't get over the size of the crowds. He laughingly told Obama one day that the crowds were an anomaly. They were of the size usually reserved for rock concerts, not political rallies. No other candidate was drawing numbers this large.

There was a reason people were so infatuated with him, and it went beyond his intelligence and likeability. During the campaign, people really did seek him out because they believed he provided hope. When he spoke of creating change, it was with a passion and

Holding room, Concord, NH, February 7, 2008

The Obamas share a quiet moment before a rally at the Concord High School gym.

a confidence that made the possibility of progress seem tangible. It wasn't unusual for people to become emotional during his speeches (p. 129). When he spoke, he spoke from the heart. He meant the words he said, and he wasn't afraid to let his own emotions show.

At a rally on Martin Luther King Jr. Day, before he won the Democratic nomination, I photographed two young men watching him greet people in the crowd (p. 168). They looked up at him in awe, as they waited patiently to meet him. Their grandmother told me, "Our young men have waited a long time to have someone to look up to, to make them believe that Dr. King's words can be true for them."

One day in Beaufort, South Carolina, I stopped to talk to two elderly African American men while Obama was taking interviews. I asked them who they thought would win the election. They said that, while they were voting for Obama, they weren't sure he could win. In order for him to get the African American vote, he had to overcome the old belief and danger of getting "too big for your britches." When I asked Obama about this, he said to me that many of us were told by our elders when we were young not to get too big for

our britches. He further explained that there was a time when it was dangerous for African Americans to appear superior to whites. It was one of the ways that whites suppressed blacks. So he had to convince voters that he could safely run for president. I realized that the men were telling me that they, and others, feared for Obama and his family as his popularity and power grew.

When he won the presidency on November 4, 2008, he signaled a new era of possibility. The week of his inauguration, I asked him if he was nervous about his speech. He said, "No, I have had it finished in my head for a while. This week is kind of like a wedding; you've just got to get to the end."

On January 20, 2009, I watched him as he waited in the wings (p. 187) to walk out and be named the forty-fourth President of the United States. I think he knew at that moment that his life would change forever when he walked through the archway in front of him and down onto the stage. But he seemed calm, and ready to get to work.

After the swearing-in, outgoing president George W. Bush seemed happy to be leaving office in Obama's hands.

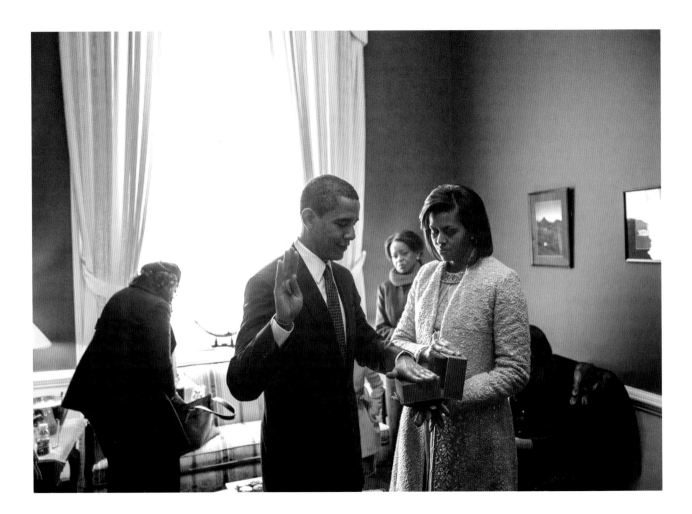

As he walked into the Capitol, he said, "Free at last," only to be corrected by former First Lady Laura Bush, who reminded him that they still had a ceremonial congressional luncheon to attend. Bush grinned and replied, "Okay, almost free." I was there the day he came into office, confident and excited. On exiting, he seemed both humbled and relieved.

So as one family exited the White House, another entered. Celebrations ensued, and that first night as President and First Lady of the United States, the Obamas attended ten official inaugural balls. In between events they stole quiet moments together (p. 133), their elatedness reminding me of college kids on a date. Obama was so proud of himself that night— he didn't step on Michelle's full-length dress once, which he noted.

(p. 133)

Holding room, United States Capitol, Washington, DC, January 20, 2009

Obama practices with Michelle before the swearing-in ceremony. One hand on the Bible, one hand raised—but not too high so as not to block his face from the cameras. President Abraham Lincoln used the same Bible for his swearing-in.

In December before the inauguration, the Obamas asked me to be the chief photographer for the White House. I would be the first woman who would have held that job from the start of an administration. But as the campaign escalated in 2008, so did my stress levels. I desperately missed watching my son grow up, and helping my husband raise him.

I would hyperventilate when I had to fly off. I found myself crying when I was around other kids. The guilt of being half a mother and wife is noted throughout my diaries, as are the hives I had all over my stomach. I had nightmares of not making it back home to Hunter. In my dreams, my plane would crash or I would lose him at rallies. I missed birthdays, Halloween, kindergarten, and first grade. At the same time, I wanted Hunter to grow up with a strong female role model like my mother—or Michelle. I was torn.

Two weeks before the inauguration, I finally concluded that I had to say, "No thank you." I knew I did not want to know more about Sasha and Malia than Hunter. I had been a White House photographer for eight years and knew it was a 24/7 job. We would have to uproot our lives in South Carolina and move back to Washington. I dreaded the conversation. But I needn't have. Michelle understood immediately. Of course, she told me that I couldn't leave Hunter and Vince. So, thanks to the Obamas, Robert Gibbs, and Pete Souza, I found a third path that let me drop in and out of the Obamas' lives for the next eight years, while holding onto my own. This would be the best for both families.

One of the positives about living at the White House was the family's literal closeness. While he still had to embark on frequent trips and manage an even busier schedule, Obama was able to see his children regularly, even if only for a moment. It meant that Sasha could spontaneously stop by to visit her father in the Oval Office (p. 144), and he could bump into Michelle and Malia in a hallway between work (p. 76). As a senator, he only saw his family on the weekends; as a presidential candidate, it could be as long as two weeks.

To survive a life in the White House, I think you have to learn how to block the world out every now and then, if only for a moment. And at times and in situations where you are anything but alone. On the dance floor at the White House (p. 137) with hundreds of people watching, the Obamas seemed to share a private celebration of their own. For me, this image captures this need for intimacy and the obvious love that the couple share. There was no denying that he was madly in love with his wife. Every time he saw her on television, or on a magazine cover, he would note how beautiful she was. Throughout the campaign she was always the one to push him back out there when

his spirits got low. She truly believed in his ability to succeed and to make America a better nation.

When they first arrived at the White House, Michelle asked the residence staff to let Sasha and Malia make their own beds and wake themselves up each morning. She wanted her girls to grow up doing things for themselves, because she understood the value in taking control of your own life.

From his days as a senator to his final year in the White House, Obama highlighted the need for equality on all fronts. As the first African American President of the United States, he was a symbol of progress in the long story of America's racial injustice. In leading the country with dignity, humor, and intelligence, he invalidated stereotypes that, for decades, had dehumanized and disenfranchised African Americans. The photograph of him sitting beneath the portrait of his fellow Illinoisan, Abraham Lincoln, marked a moment that I had long hoped for (p. 163). Not only was the nation's first African American president seated in the State Dining Room, but so was an entire table of African American leaders. For me this photograph reflected that times were changing in Washington, DC.

The Obamas' natural capacity for love and empathy enabled people to see their genuine nature because it was that—genuine. One day he asked me why I had chosen to photograph him in the beginning, before he was in the spotlight. I told him it was because he was nice, and I could tell that he was a good person. And sometimes, as he proved, being respectful, and nice, and a decent person, does work in your favor. They were not born-and-bred politicians, they did not come from old money, they did not have a long family history in politics. They experienced things that most people experience during the formative years of their life. Because of this, they were able to understand, and even relate to, some of the stories that everyday Americans shared with them.

It is impossible to watch and know Michelle and believe that anyone would call her "an angry black woman," however during the campaign some people did. I think because they feared her strength and ability to empower others. It was obvious when around her that these remarks privately pained her. It was even more obvious how completely out of character it was. Her ability to connect with people and pull them in was incredible. She had been her husband's

sanctuary, best friend, and confidante, and their teamwork continued into his presidency.

Knowing that meeting the First Lady can be intimidating for young people, Michelle would purposefully touch and hug them, to show them that she was real, and that the moment was real. In the early years of her initial term as First Lady, on a visit to Anacostia High School in Washington, DC, she told students that they could ask her anything they wanted (pp. 79, 82). Soon after, one of the students asked: "Do you do your own hair and makeup?" Being able to ask such personal questions and get a direct answer was her way of letting them know that she was a normal person, who wanted to have a normal conversation.

Obama began as a community organizer, dealing with one personal problem at a time. Later, as a state senator, dealing with one state. Things are different as president; your decisions affect an entire nation, and often the world. Coupled with the extreme weight of this is the stifling pressure of living a life that is constantly in the spotlight. The White House is a museum that the First Family of the United States happens to live in. They are a part of the museum.

Five days a week, tourists go through the Blue Room, right underneath the family's living space. For a job where you are rarely alone, the office of the president can be one of the loneliest. As he adapted to life in the White House, Obama told me one day that he felt like he was living in a museum, or a bubble (p. 150). You had to learn to adjust to your new surroundings, or you would not survive.

A year into office, while in his limousine as he read the paper (p. 101), I asked him if he was glad he had taken on the presidency. He acknowledged that there was no going back now, but said yes, he was glad. People would always ask me if I felt he changed while in office. To me, a person does not change in their role as president; instead I think the office reveals who you are. I felt the presidency gave him a place where his way of governing and listening seemed to work best.

There is no denying that times have changed since the Obamas left the White House. But the journey—from my first glimpse of a young legislator sitting on a stool in the Chicago Union Hall in 2004 (p. 6), to his feet on the desk in the Oval Office (p. 182)—did not change him, or the values he espoused.

In a 2011 interview in Phoenix, Arizona, Michelle spoke of fear. She asked people to make decisions not out of fear, but out of hope—hope for a better future.

Fear is corrosive. It has the power to transform worry into hatred and resentment, to generate irrational and illogical thoughts, to prevent people from following the path they desire. Fear is a method used by the weak; by those who do not know how to lead, or how to empower. It is taught through ignorance and keeps people uninformed. Every weak person in history has used fear to govern and control. Fear is weakness.

When I think of Obama's path to the presidency— when I think of Barack and Michelle Obama—it is hope that comes to mind. They provided hope to others, because they were an example of what is possible.

Hope is what sustains us in difficult times. It is what brings us out of despair, and what helps us defeat seemingly insurmountable obstacles. It is what motivates us to strive for our goals, whatever they may be. And it matters now, more than ever.

So to every child, young person, and adult who worries they are different, or doubts their worth, I hope the images and words in this book show that anything is possible. We are all born equal, with a heart, a brain, and a soul. If you push for what is right, and good, you can overcome any adversity. I hope sharing the Obamas' journey empowers people of all ages, races, and genders to believe in themselves, and to use their voices to take control of their future.

You do not need me, or the Obamas, to tell you these truths. But if this book helps you believe them, then it has served its purpose.

Fear is caused by cowards. Hope creates heroes.

—Callie Shell

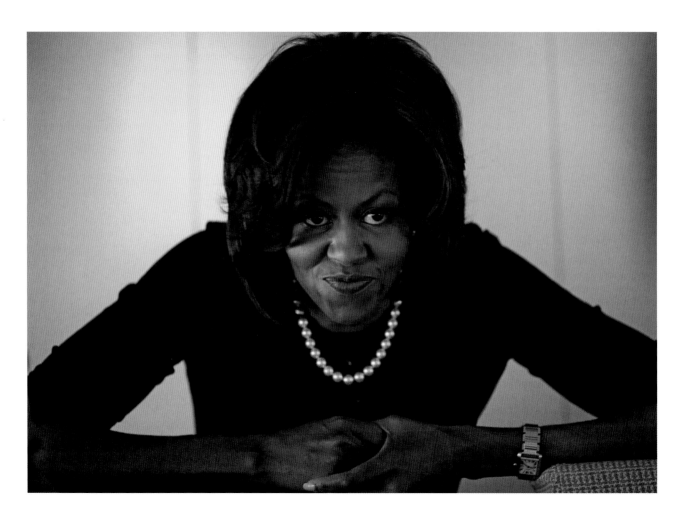

"I want our young people to know that they matter, that they belong. So don't be afraid. You hear me, young people? Don't be afraid. Be focused. Be determined. Be hopeful. Be empowered. Empower yourself with a good education. Then get out there and use that education to build a country worthy of your boundless promise. Lead by example with hope; never fear."

—MICHELLE OBAMA

"It's tempting right now to give in to cynicism. To believe that recent shifts in global politics are too powerful to push back. That the pendulum has swung permanently. And just as people spoke about the triumph of democracy in the nineties, now you are hearing people talk about the end of democracy and the triumph of tribalism and the strong man . . . If you know what's in your heart, and you're willing to sacrifice for it, even in the face of overwhelming odds, that it might not happen tomorrow, it might not happen next week, it might not even happen in your lifetime. Things may go backwards for a while, but ultimately right makes might—not the other way around. Ultimately, the better story can win out."

—BARACK OBAMA

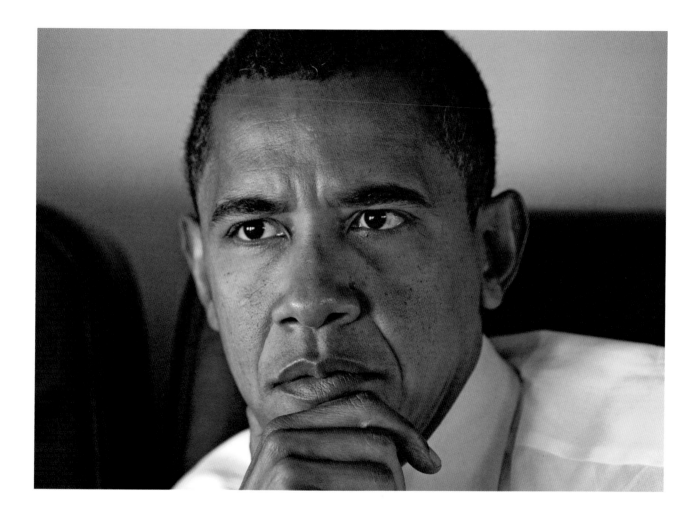

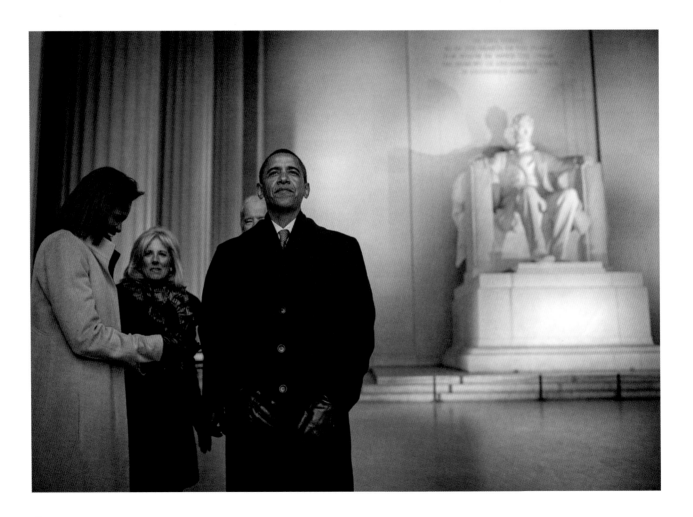

"We don't just need one leader. We don't just need one
 inspiration. What we badly need right now is that collective
 spirit. And I know that those young people, those hope-
 carriers, are gathering around the world. Because history
 shows that, whenever progress is threatened and the things
 we care about most are in question, we should heed the words
 of Robert Kennedy . . . 'our answer is the world's hope. It is to
 rely on youth. It's to rely on the spirit of the young.' So young
 people . . . My message to you is simple. Keep believing:
 Keep marching. Keep building. Keep raising your voice.
 Every generation has the opportunity to remake the world."

—BARACK OBAMA

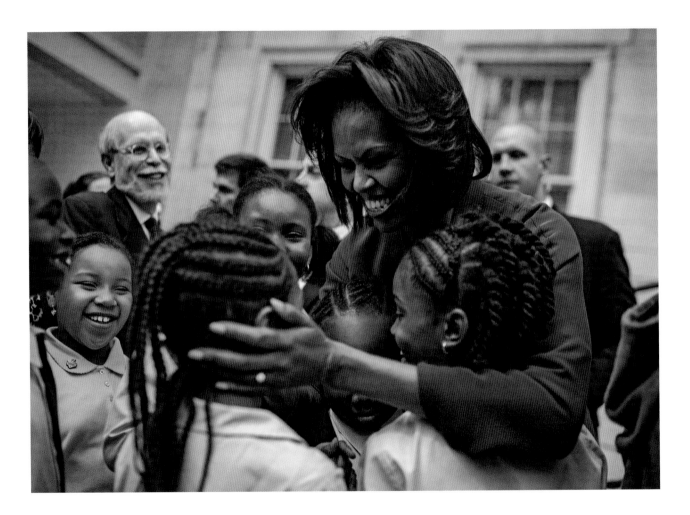

"To the young people here, and the young people out there:
Do not ever let anyone ever make you feel like you don't matter,
or like you don't have a place in our American story—because
you do. And you have a right to be exactly who you are. But I
also want to be very clear: This right isn't just handed to you.
No, this right has to be earned every single day. You cannot take
your freedoms for granted."

—MICHELLE OBAMA

"I see Americans of every party, every background, every faith who believe that we are strong together: Black, white, Latino, Asian, Native American; young, old; gay, straight; men, women; folks with disabilities."

—BARACK OBAMA

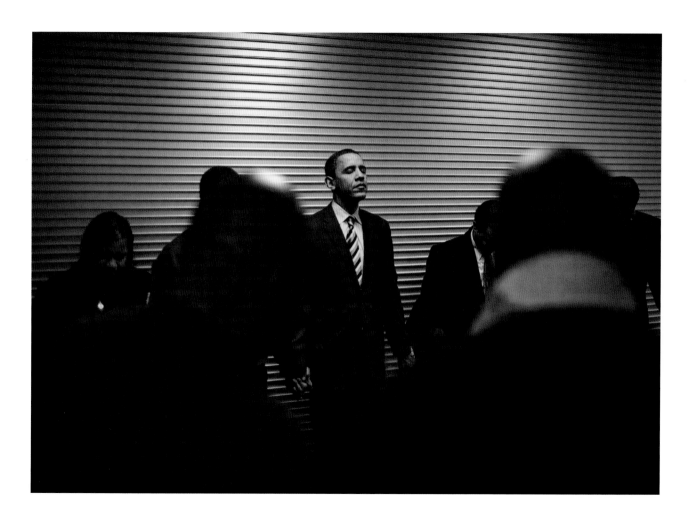

"Barack and I were raised with so many of the same values, like you work hard for what you want in life. That your word is your bond. That you do what you say you're going to do. That you treat people with dignity and respect, even if you don't know them and even if you don't agree with them."

—MICHELLE OBAMA

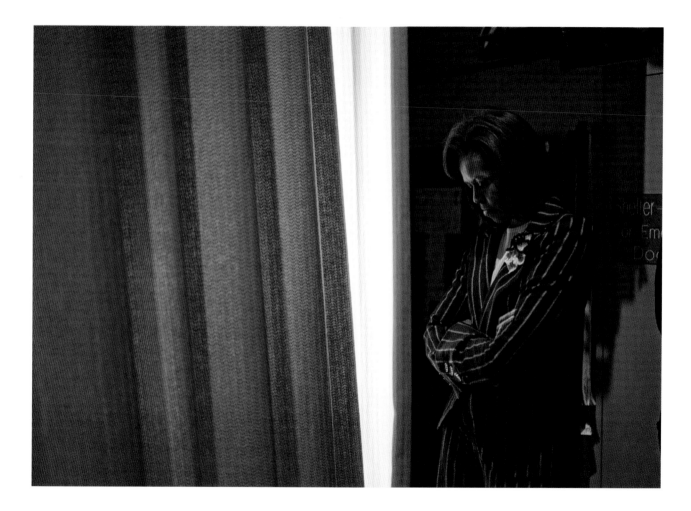

"When I think about how I understand my role as citizen, setting aside being president, and the most important set of understandings that I bring to that position of citizen, the most important stuff I've learned I think I've learned from novels. It has to do with empathy. It has to do with being comfortable with the notion that the world is complicated and full of grays, but there's still truth there to be found, and that you have to strive for that and work for that."

—BARACK OBAMA

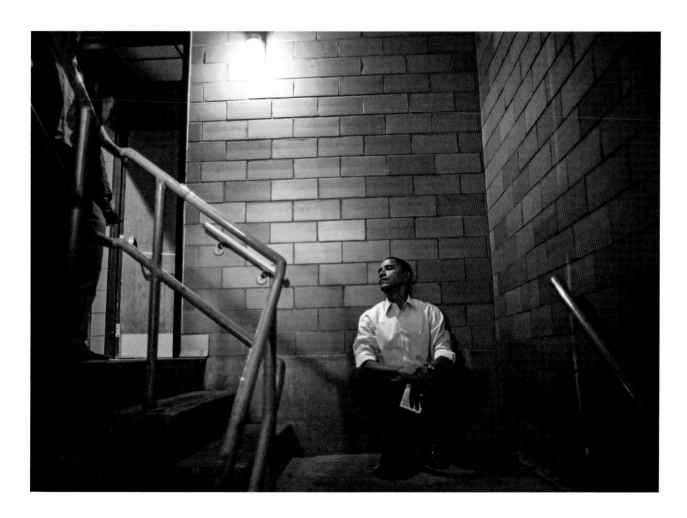

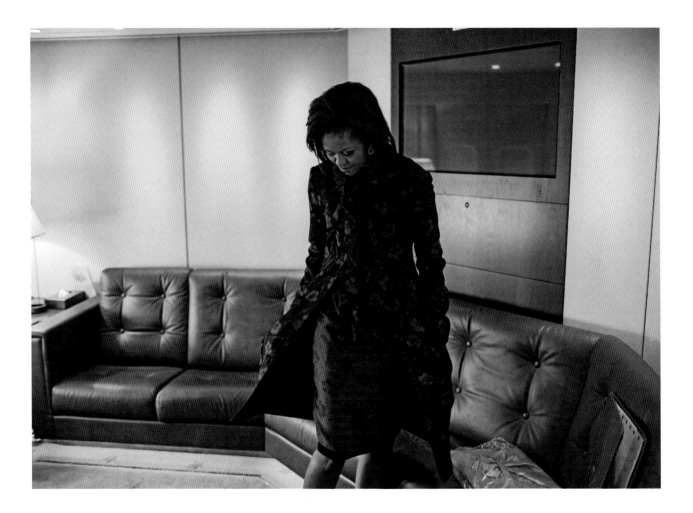

"I am an example of what is possible when girls from the very beginning of their lives are loved and nurtured by people around them. I was surrounded by extraordinary women in my life who taught me about quiet strength and dignity."

—MICHELLE OBAMA

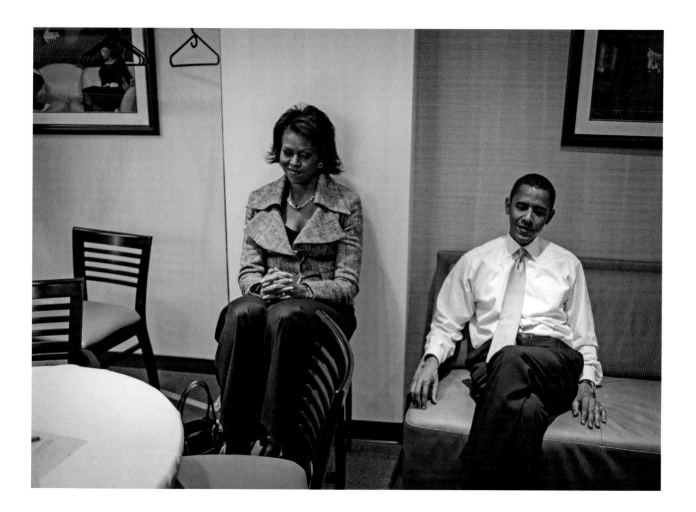

"The difference between a broken community and a thriving one
is the presence of women who are valued."

—MICHELLE OBAMA

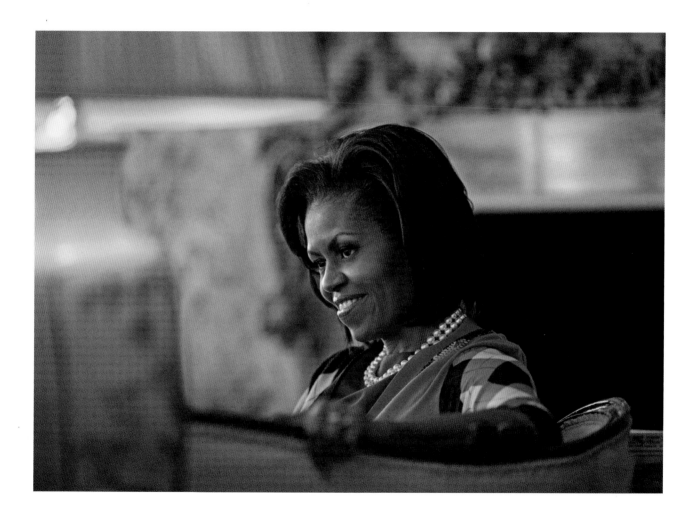

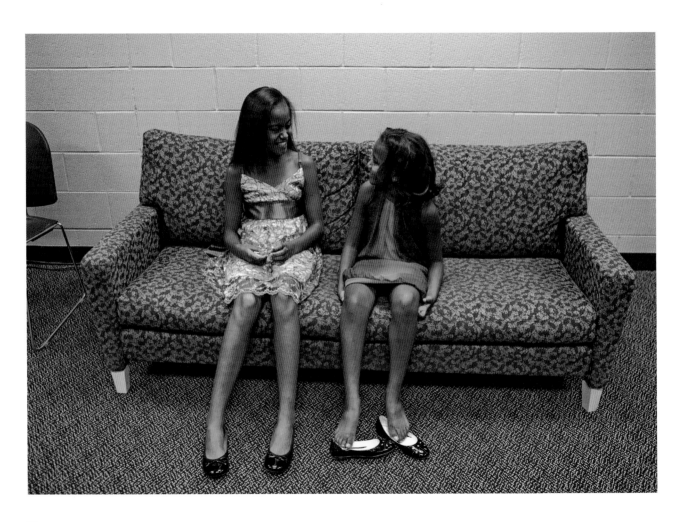

"It's important that their dad is a feminist, because now that's what they expect from all men."

—BARACK OBAMA

"No country can ever truly flourish if it stifles the potential of its women and deprives itself of the contributions of half its citizens."

—MICHELLE OBAMA

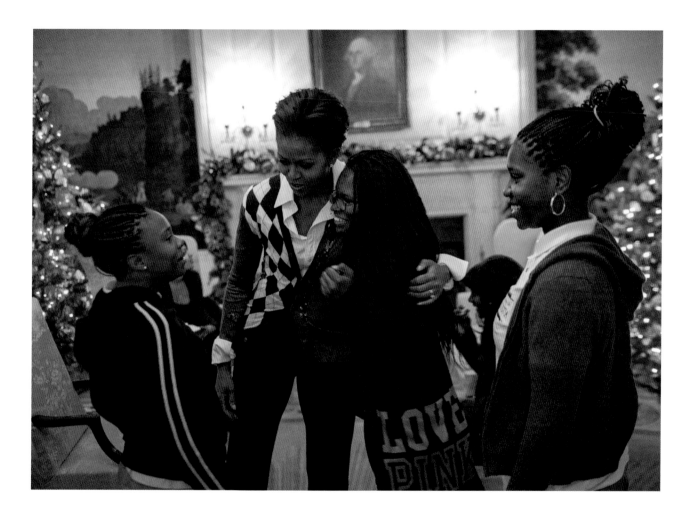

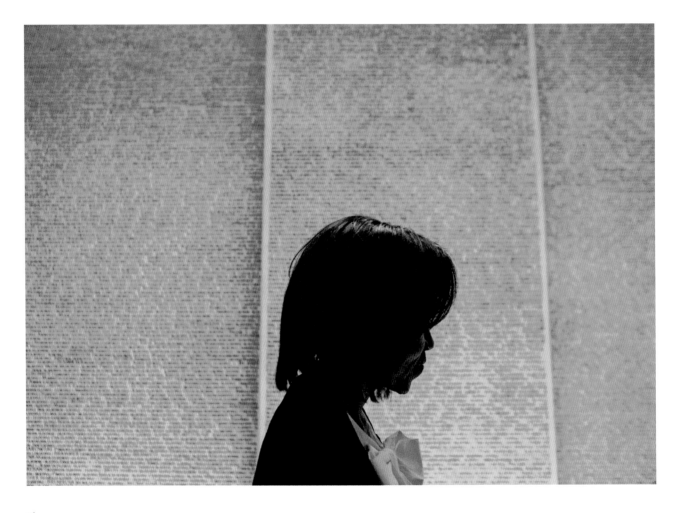

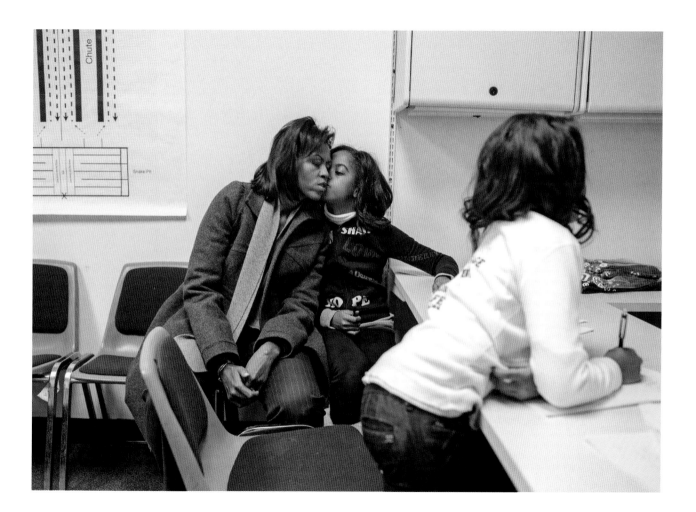

"We shouldn't downplay how far we've come. That would do a disservice to all those who spent their lives fighting for justice. At the same time, there's still a lot of work we need to do to improve the prospects of women and girls here and around the world."

—BARACK OBAMA

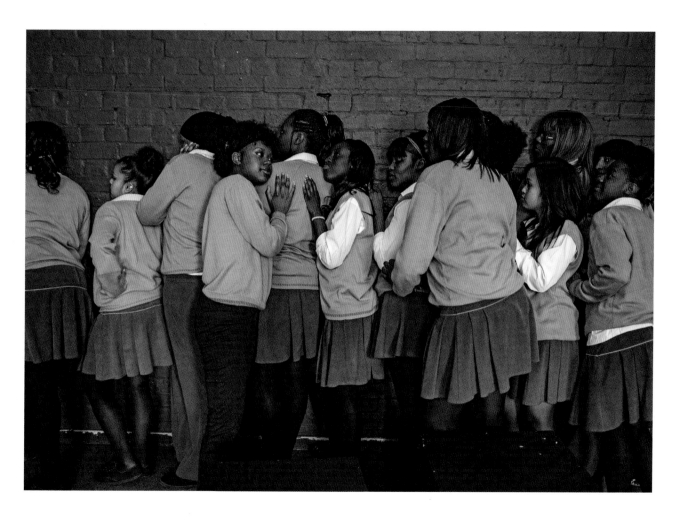

"That's what twenty-first century feminism is all about: The idea that when everybody is equal, we are all more free."

—BARACK OBAMA

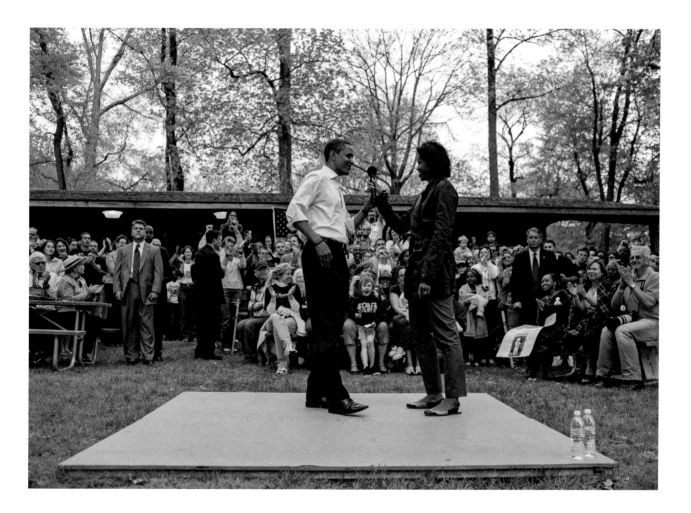

"Gender stereotypes affect all of us, regardless of our gender,
gender identity, or sexual orientation. But I also have to admit
that when you're a father of two daughters, you become even
more aware of how gender stereotypes pervade our society . . .
You feel the enormous pressure girls are under to look and
behave and even think a certain way."

—BARACK OBAMA

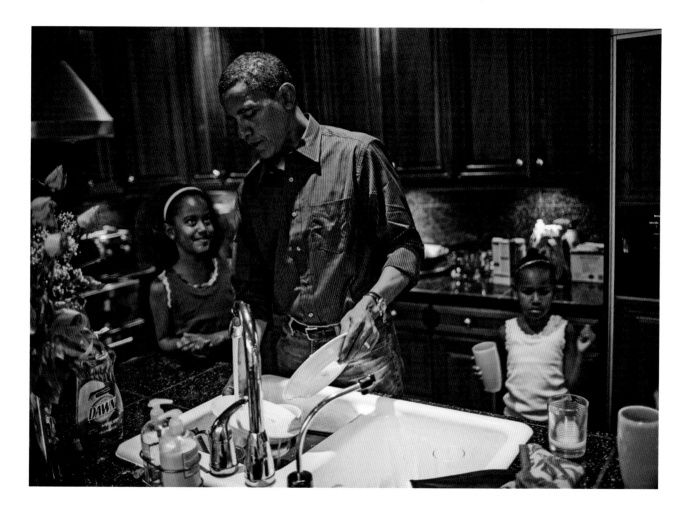

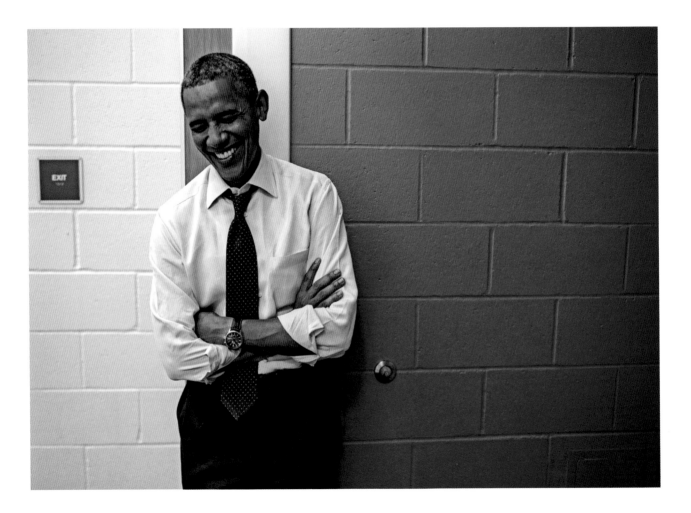

"I may be a little grayer than I was eight years ago, but this is what a feminist looks like."

—BARACK OBAMA

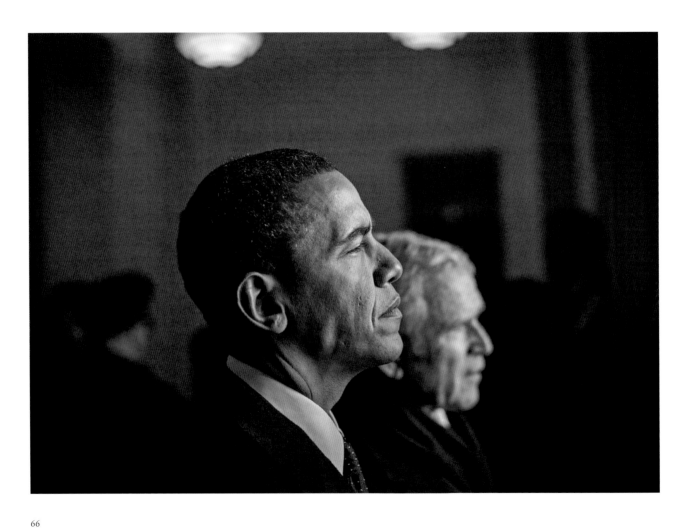

"I love that for Barack, there is no such thing as 'us' and 'them'—
he doesn't care whether you're a Democrat, a Republican, or
none of the above . . . he knows that we all love our country . . .
and he's always ready to listen to good ideas . . . he's always
looking for the very best in everyone he meets."

—MICHELLE OBAMA

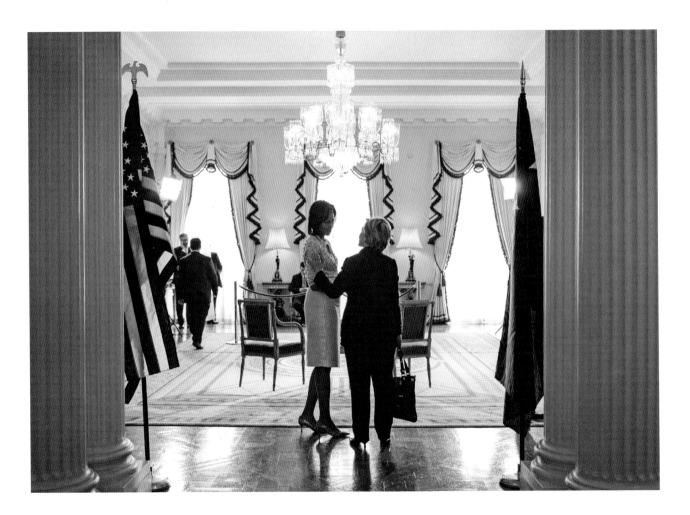

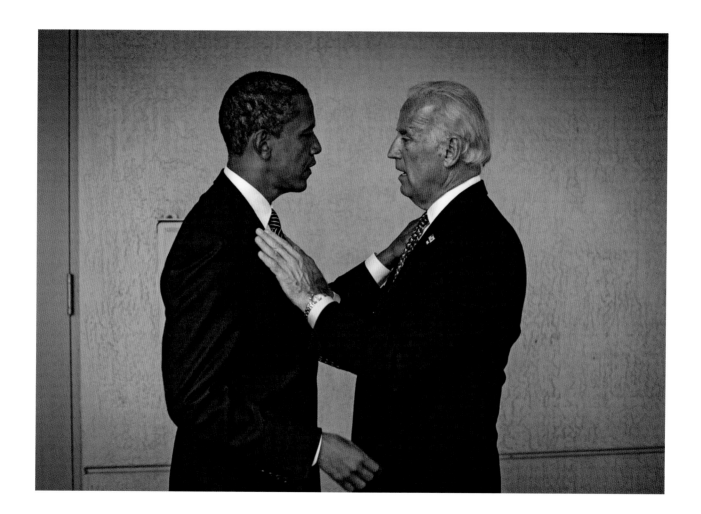

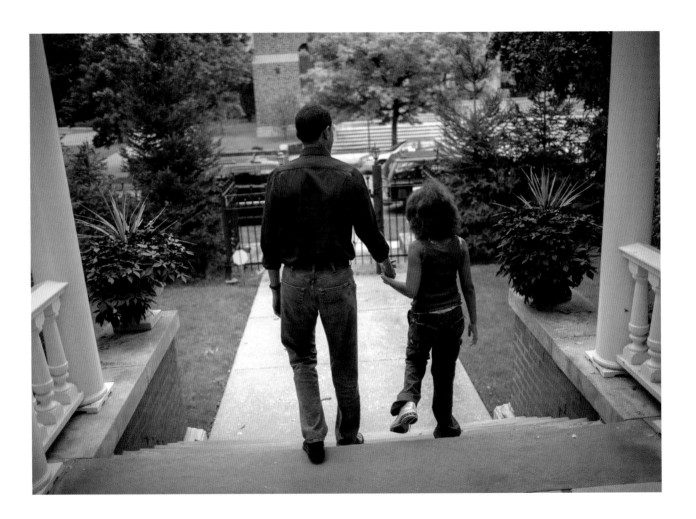

"We pass on the values of empathy and kindness to our children by living them."

—BARACK OBAMA

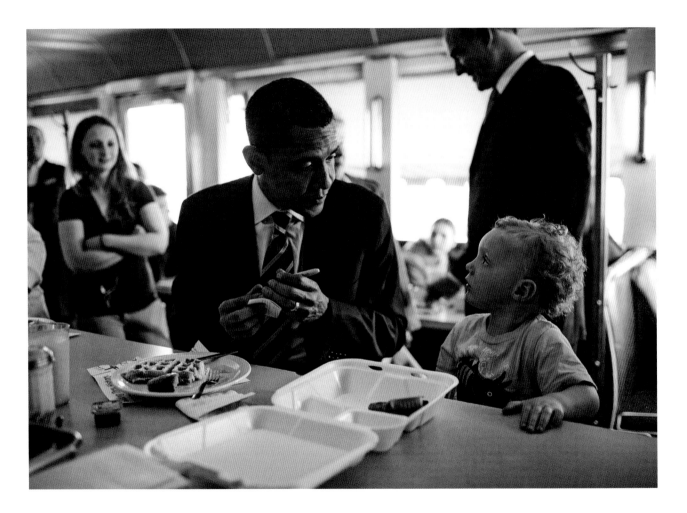

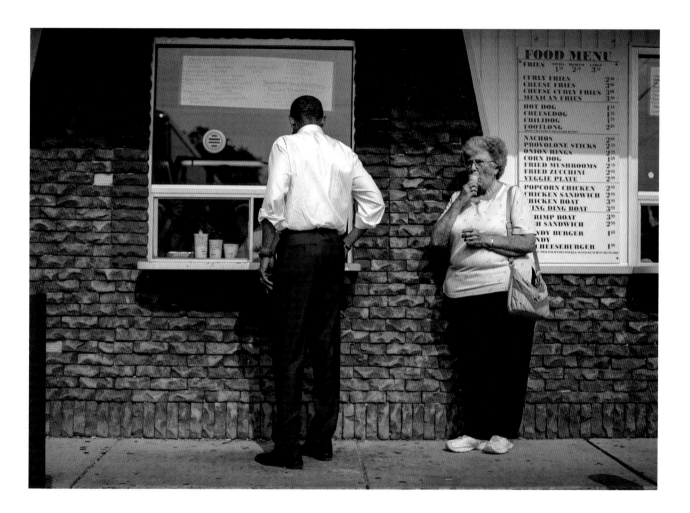

73

"Any fool can have a child. That doesn't make you a father.
It's the courage to raise a child that makes you a father."

—BARACK OBAMA

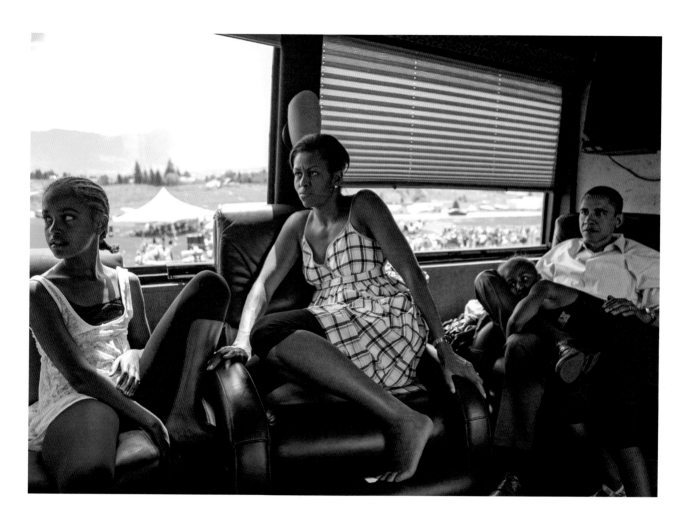

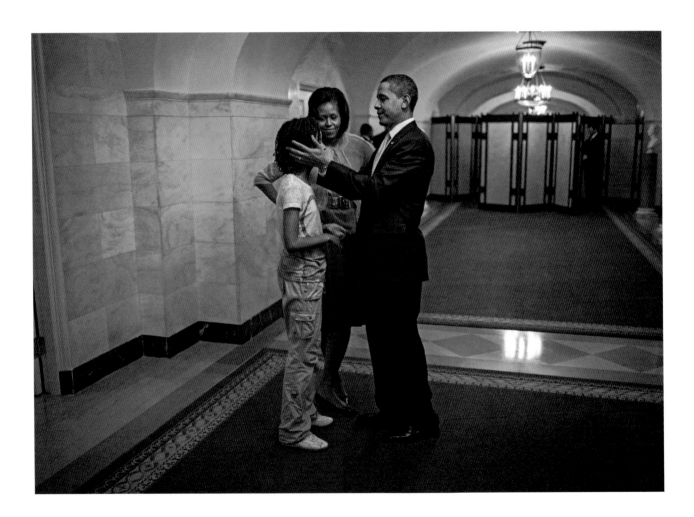

"As fathers, we need to be involved in our children's lives not just when it's convenient or easy, and not just when they're doing well—but when it's difficult and thankless, and they're struggling. That is when they need us most."

—BARACK OBAMA

"Every day, you have the power to choose our better history—
by opening your hearts and minds; by speaking up for what
you know is right."

—MICHELLE OBAMA

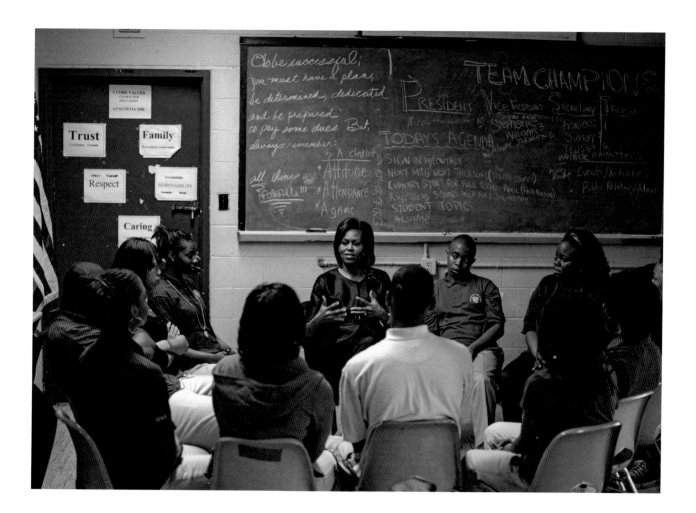

79

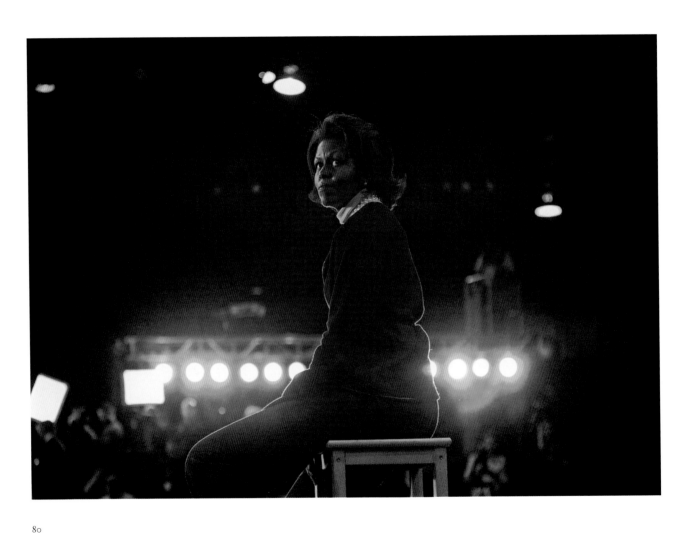

"When someone is cruel, or acts like a bully, you don't stoop to their level. No, our motto is, when they go low, we go high."

—MICHELLE OBAMA

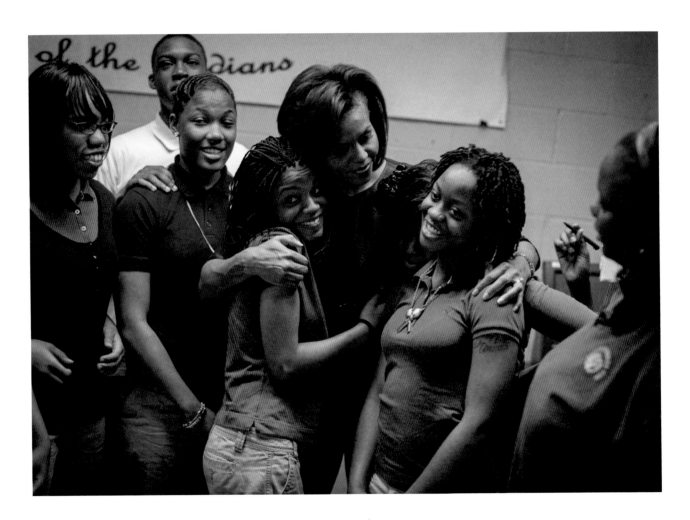

"Do not bring people in your life who weigh you down, and trust your instincts. Good relationships feel good. They feel right. They don't hurt. They're not painful. That's not just with somebody you want to marry, but it's with the friends you choose. It's with the people you surround yourself with."

—MICHELLE OBAMA

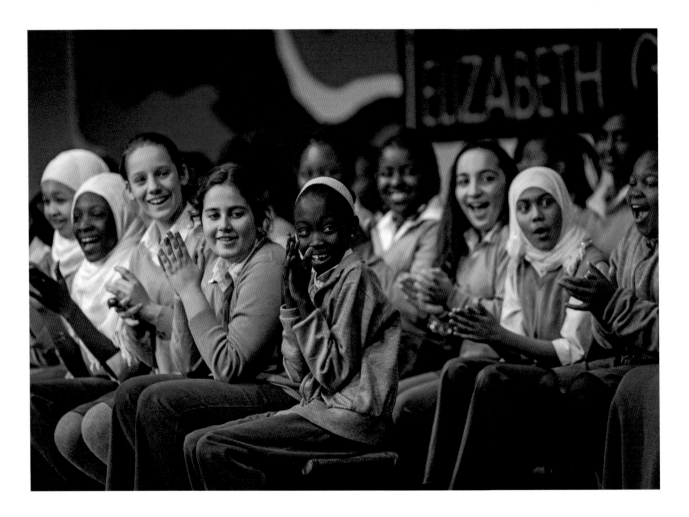

"We need to fix our souls. Our souls are broken in this nation. We have lost our way. And it begins with inspiration. It begins with leadership."

—MICHELLE OBAMA

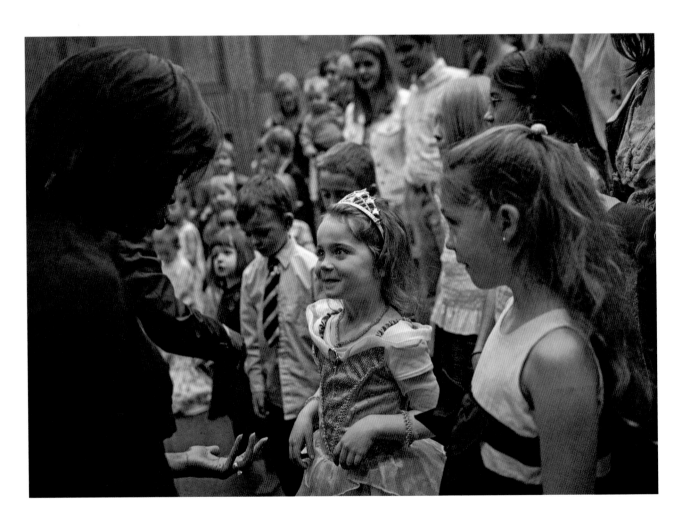

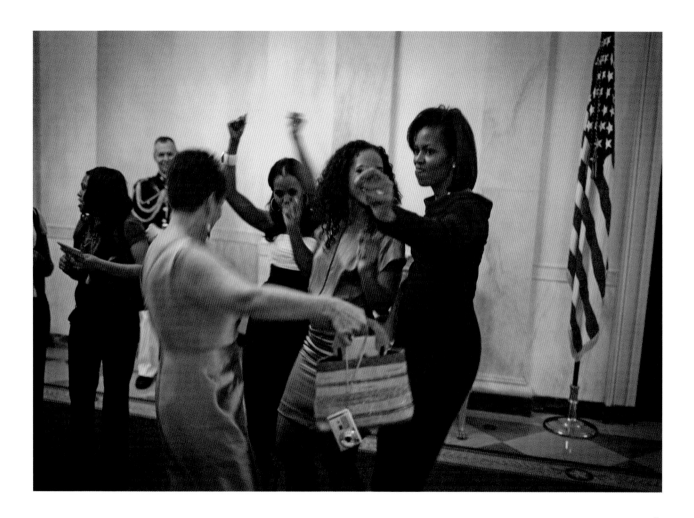

"You cannot take your freedoms for granted. Just like generations who have come before you, you have to do your part to preserve and protect those freedoms . . . you need to be preparing yourself to add your voice to our national conversation."

—MICHELLE OBAMA

"We, the People, recognize that we have responsibilities as well as rights; that our destinies are bound together; that a freedom which only asks what's in it for me, a freedom without a commitment to others, a freedom without love or charity or duty or patriotism, is unworthy of our founding ideals and those who died in their defense."

—BARACK OBAMA

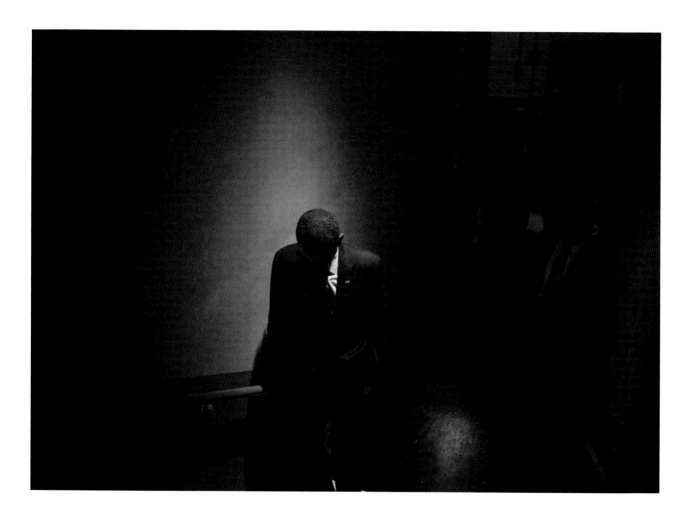

"You may not always have a comfortable life and you will not always be able to solve all of the world's problems at once, but don't ever underestimate the impact you can have, because history has shown us that courage can be contagious and hope can take on a life of its own."

—MICHELLE OBAMA

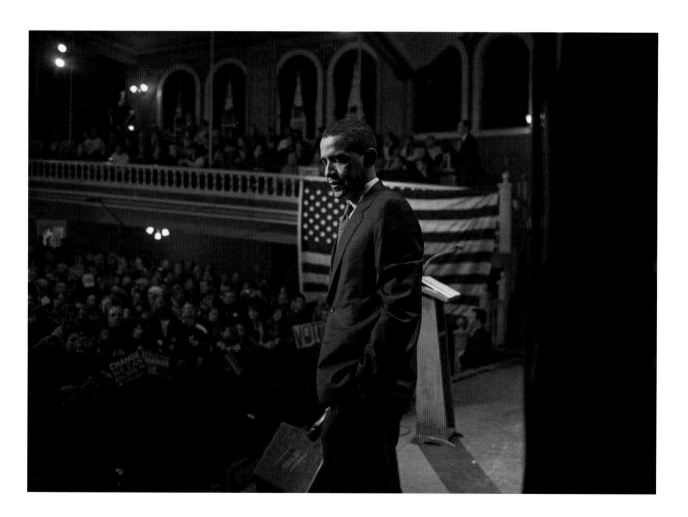

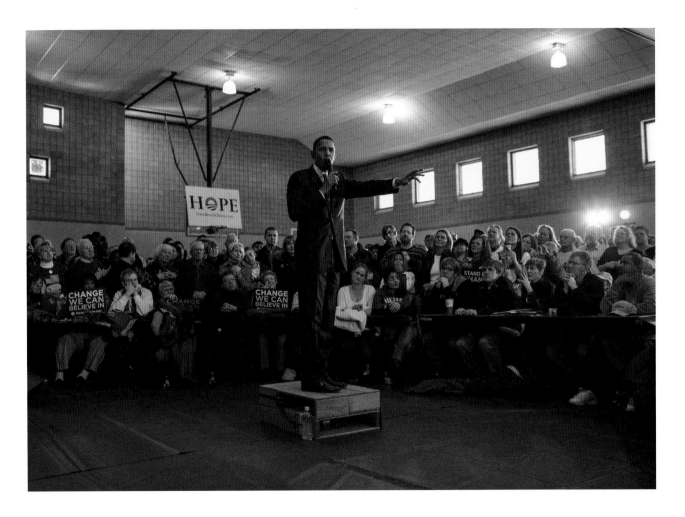

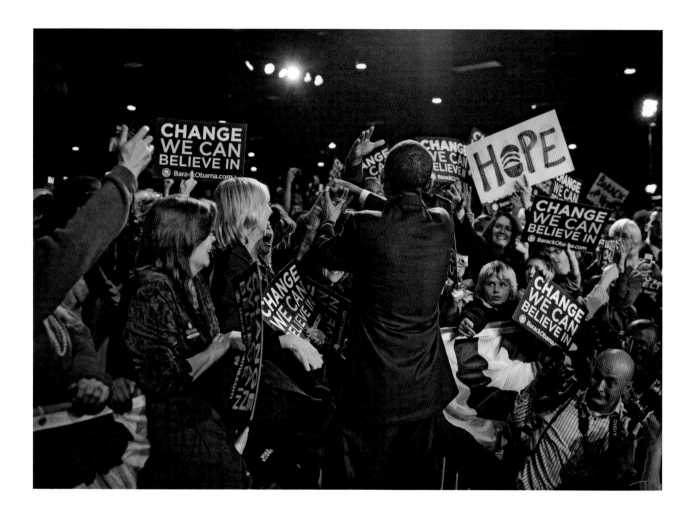

"Building a purposeful life for yourself is never easy. No one achieves success overnight. You know life doesn't work that way. Anything worth having takes time and perseverance."

—MICHELLE OBAMA

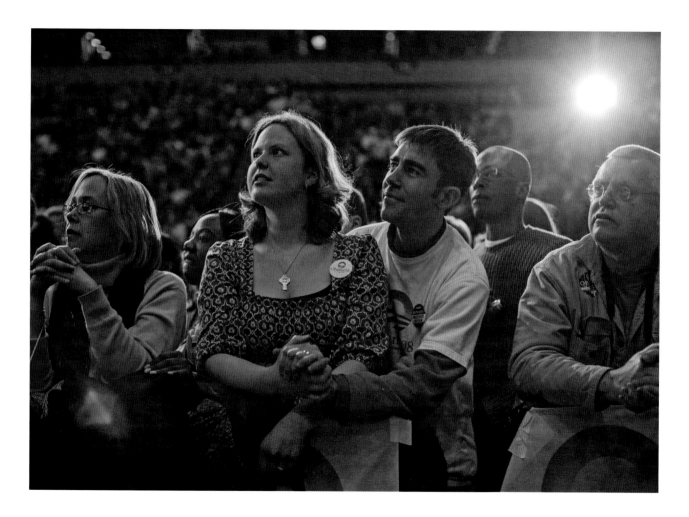

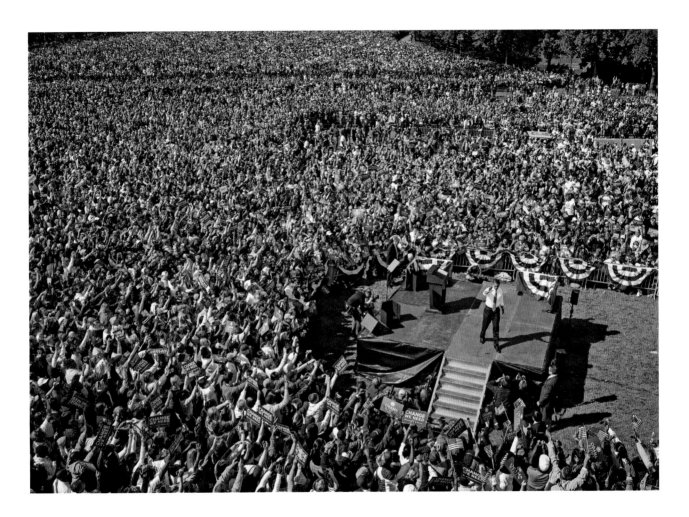

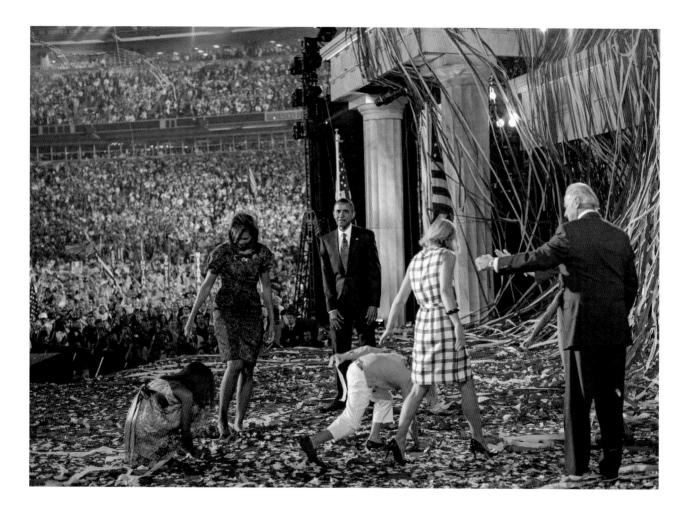

"I try to focus not on the fumbles, but on the next plan."

—BARACK OBAMA

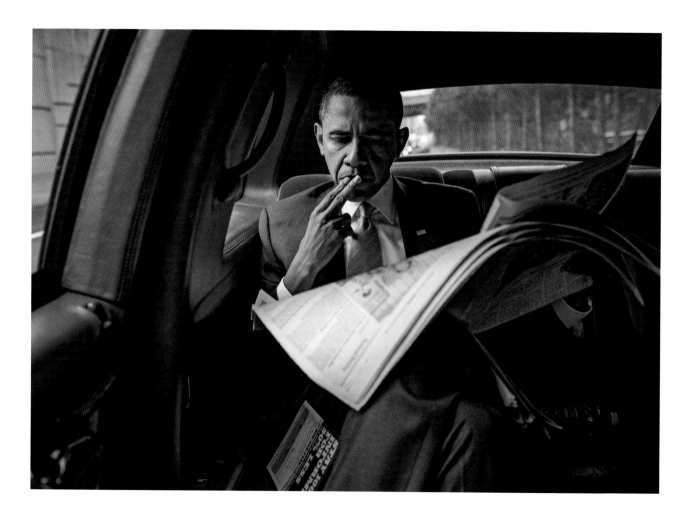

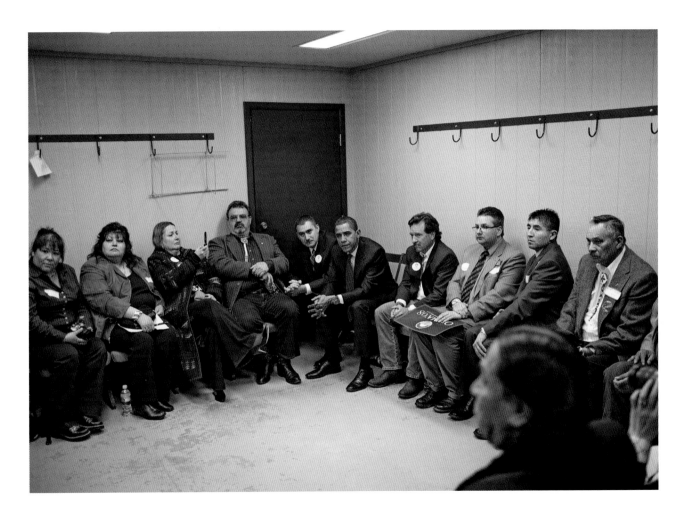

"For all its imperfections, real democracy best upholds the idea that government exists to serve the individual, and not the other way around. And it is the only form of government that has the possibility of making that idea real. So for those of us that are interested in strengthening democracy, it's time for us to stop paying all of our attention to the world's capitals and the center of power, and to start focusing more on the grassroots, because that's where democratic legitimacy comes from. Not from the top down, not from abstract theories, not just from experts, but from the bottom up. Knowing the lives of those who are struggling."

—BARACK OBAMA

"We also have to keep teaching our children and ourselves—and this is really hard—to engage with people who not only look different but who hold different views. This is hard. Most of us prefer to surround ourselves with opinions that validate what we already believe. You notice the people who you think are smart, are the people who agree with you. Funny how that works. But democracy demands that we're able also to get inside the reality of people who are different than us, so we can understand their point of view. Maybe we can change their minds, but maybe they'll change ours."

—BARACK OBAMA

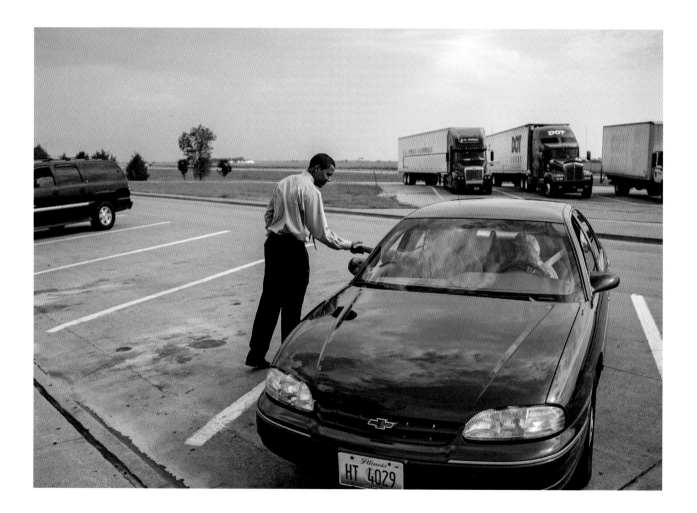

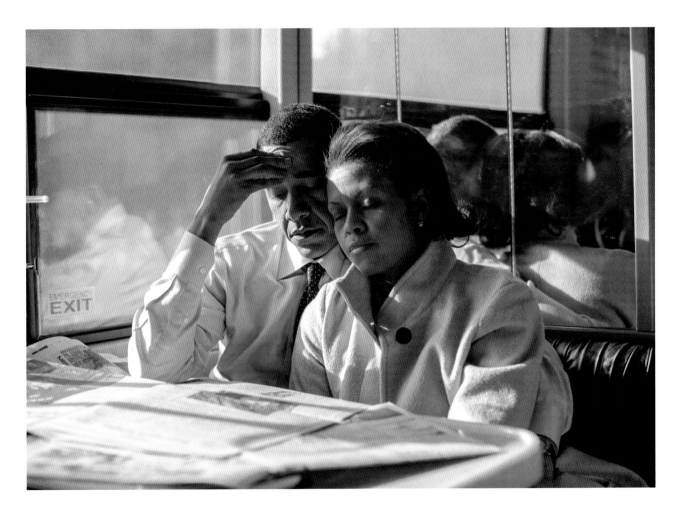

"When you are struggling, and you start thinking about giving up, I want you to remember something that my husband and I have talked about since we first started this journey nearly a decade ago . . . that is the power of hope. The belief that something better is always possible if you're willing to work for it and fight for it."

—MICHELLE OBAMA

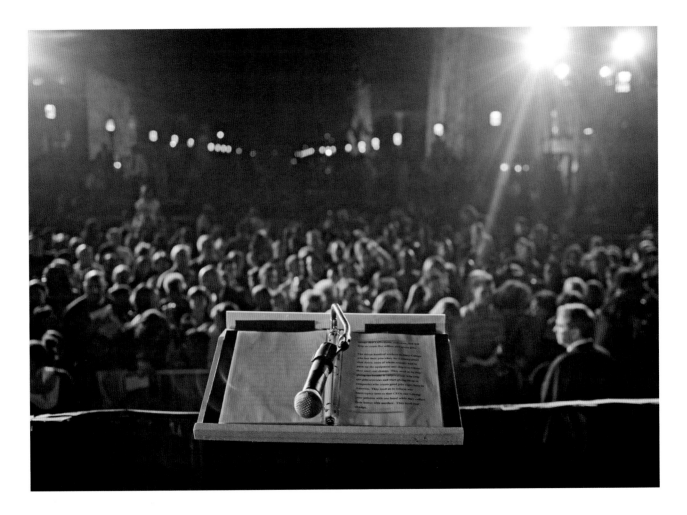

"Don't ever scale back your dreams. And don't ever set limits on what you can achieve. And don't think for one single moment that your destiny is out of your hands, because no one's in control of your destiny but you. And it is never too late."

—MICHELLE OBAMA

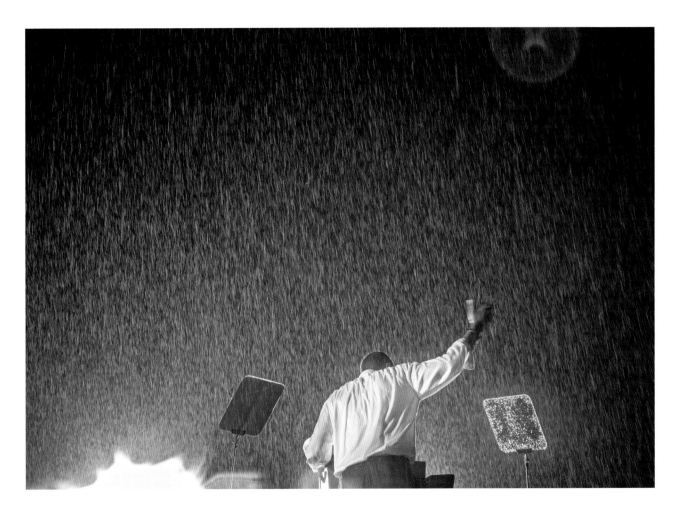

"Change will not come if we wait for some other person or some other time. We are the ones we've been waiting for. We are the change that we seek."

—BARACK OBAMA

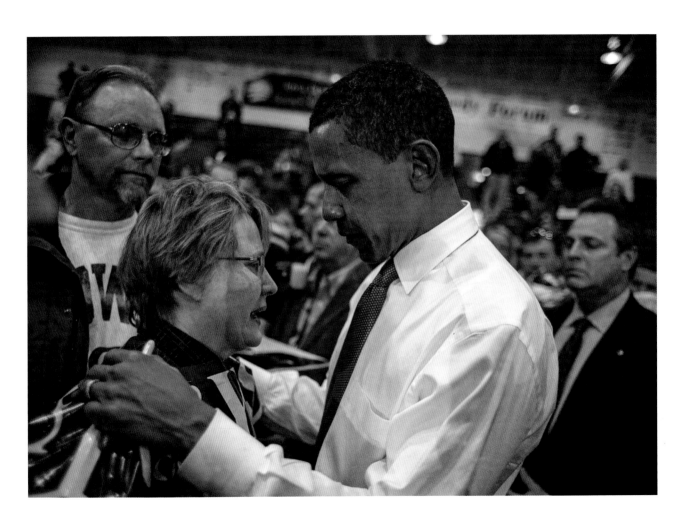

"As a community organizer I learned as much from a laid-off steelworker in Chicago, or a single mom in a poor neighborhood that I visited, as I learned from the finest economists in the Oval Office. Democracy means being in touch and in tune with life as it's lived in our communities. And that's what we should expect from our leaders. And it depends upon cultivating leaders at the grassroots, who can help bring about change and implement it on the ground, and who tell leaders in fancy buildings, this isn't working down here."

—BARACK OBAMA

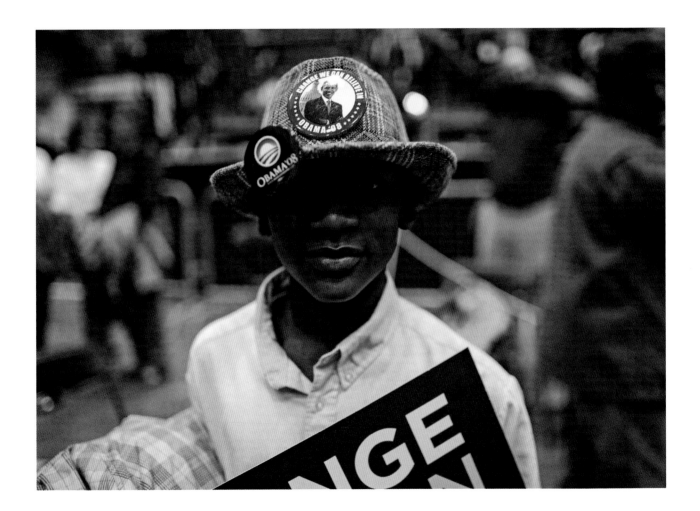

"Success isn't about how much money you make; it's about the difference you make in people's lives."

—MICHELLE OBAMA

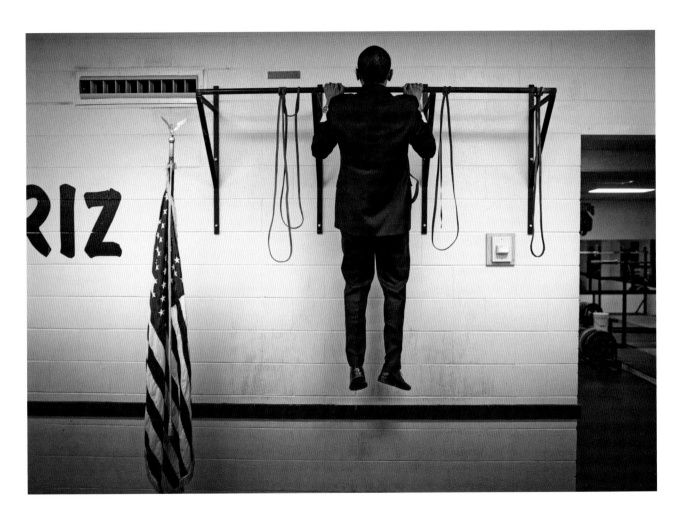

"It's easy to absorb all kinds of messages from society about masculinity and come to believe that there's a right way and a wrong way to be a man. But as I got older, I realized that my ideas about being a tough guy or cool guy just weren't me. They were a manifestation of my youth and insecurity. Life became a lot easier when I simply started being myself."

—BARACK OBAMA

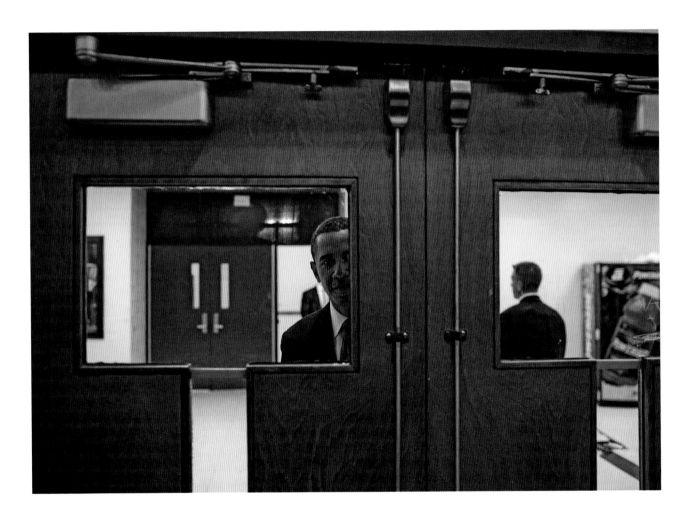

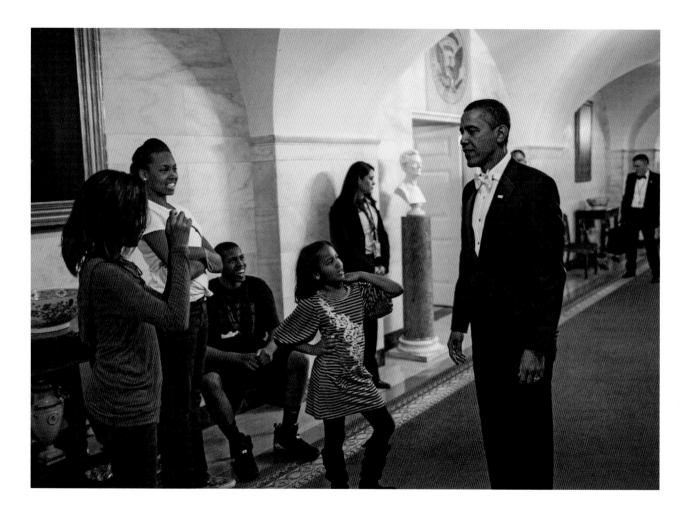

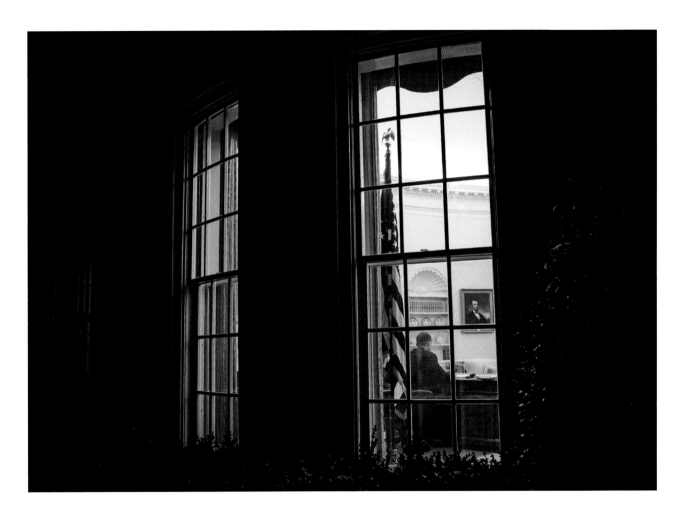

"When we don't pay close attention to the decisions made by our leaders, when we fail to educate ourselves about the major issues of the day, when we choose not to make our voices and opinions heard, that's when democracy breaks down. That's when power is abused. That's when the most extreme voices in our society fill the void that we leave. That's when powerful interests and their lobbyists are most able to buy access and influence in the corridors of power—because none of us are there to speak up and stop them."

—BARACK OBAMA

"If we want maturity, we have to be mature. If we want a nation that feels hopeful, then we have to speak in hopeful terms . . . We have to model what we want."

—MICHELLE OBAMA

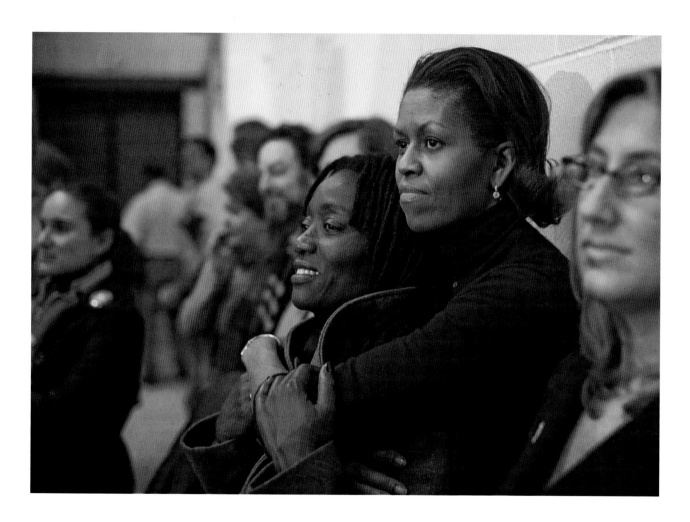

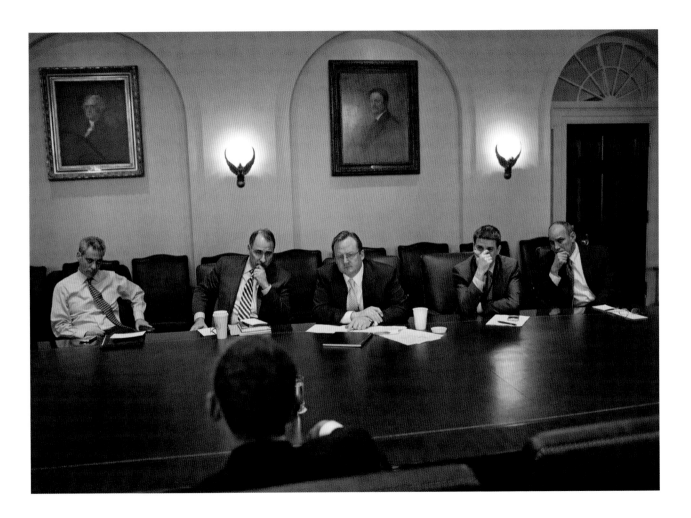

"Change depends on our actions, on our attitudes, the things we teach our children. And if we make such an effort, no matter how hard it may sometimes seem, laws can be passed, and consciences can be stirred, and consensus can be built."

—BARACK OBAMA

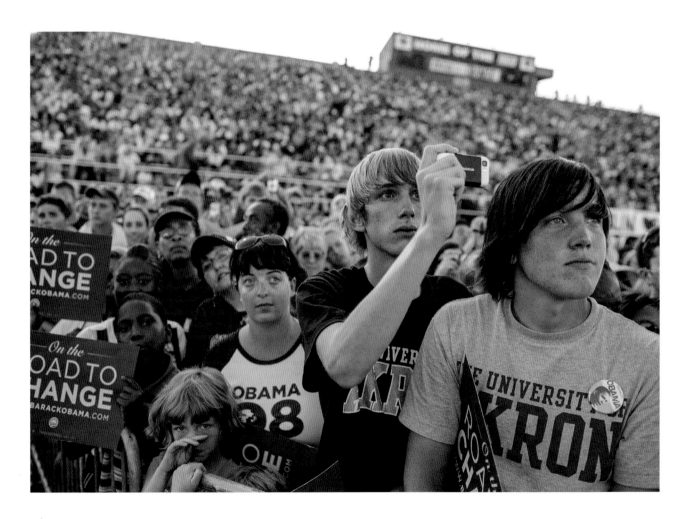

"Everywhere in this country there are first steps to be taken, there is new ground to cover, there are more bridges to be crossed. And it is you, the young and fearless at heart, the most diverse and educated generation in our history, who the nation is waiting to follow."

—BARACK OBAMA

"It is our fundamental belief in the power of hope that has allowed us to rise above the voices of doubt and division, of anger and fear that we have faced in our own lives and in the life of this country. Our hope that if we work hard enough and believe in ourselves, then we can be whatever we dream, regardless of the limitations that others may place on us."

—MICHELLE OBAMA

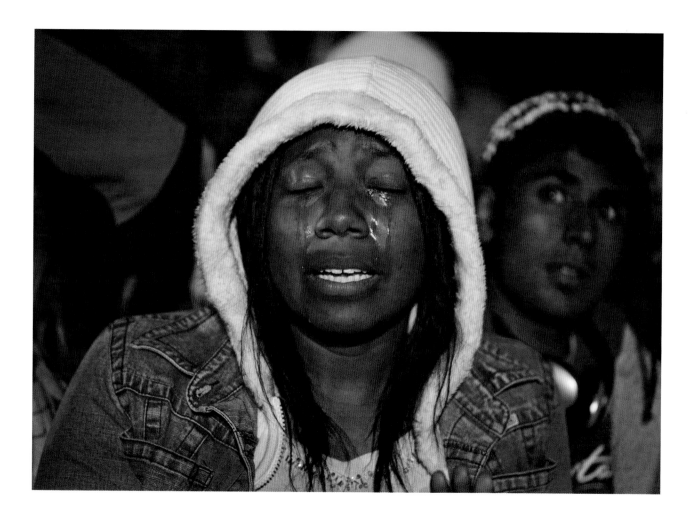

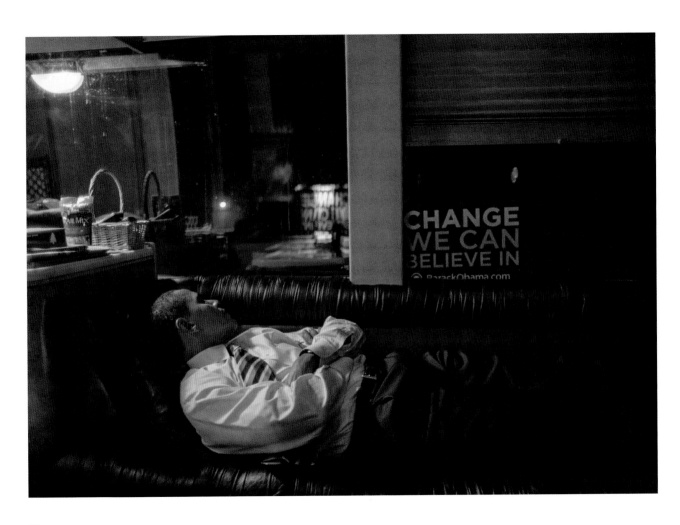

"Loving this country requires more than singing its praises or avoiding uncomfortable truths. It requires the occasional disruption. The willingness to speak out for what is right, to shake up the status quo."

—BARACK OBAMA

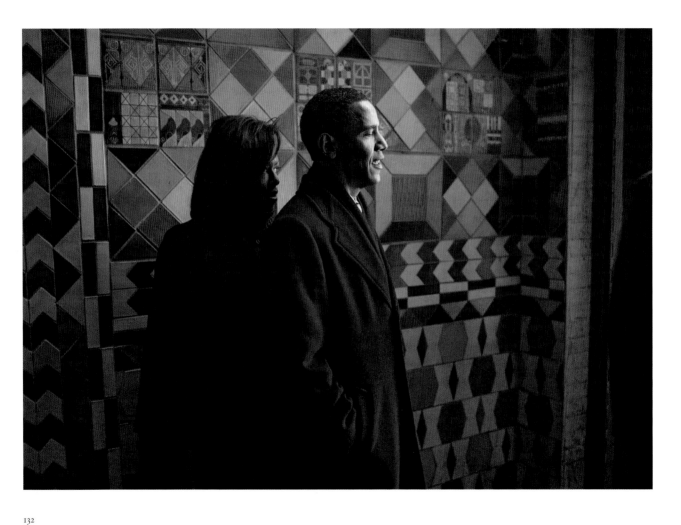

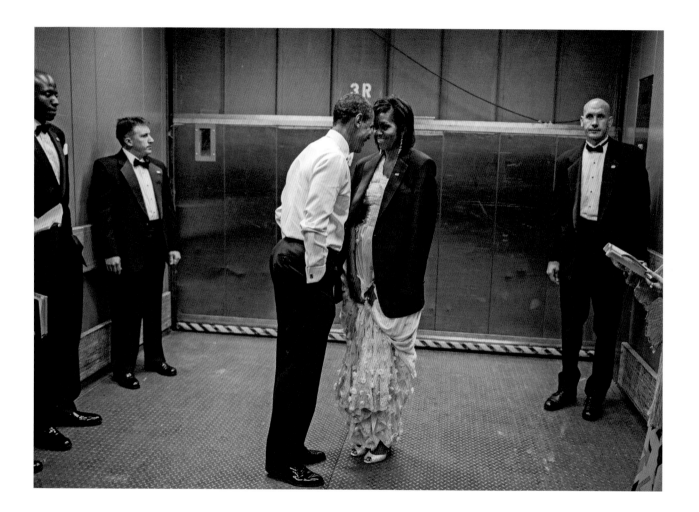

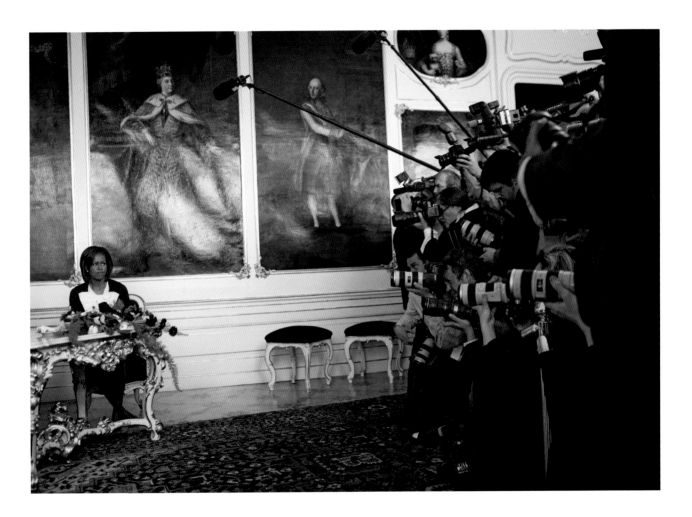

"One of the lessons that I grew up with was to always stay true to yourself and never let what somebody else says distract you from your goals."

—MICHELLE OBAMA

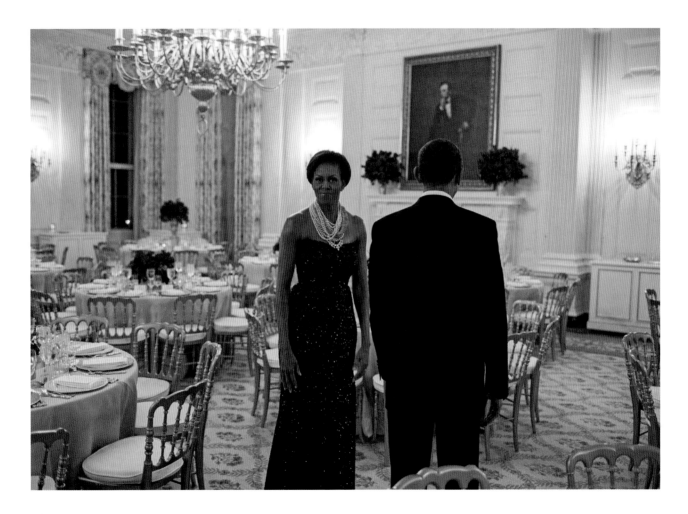

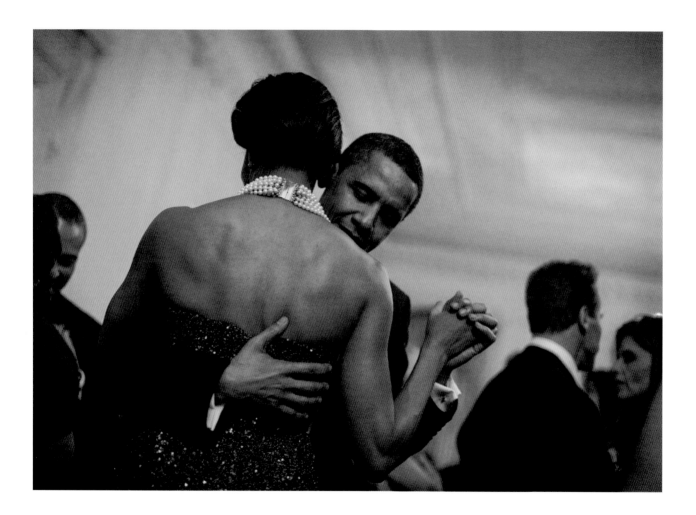

"We learned about honesty and integrity—that the truth matters . . . that you don't take shortcuts or play by your own set of rules . . . and success doesn't count unless you earn it fair and square."

—MICHELLE OBAMA

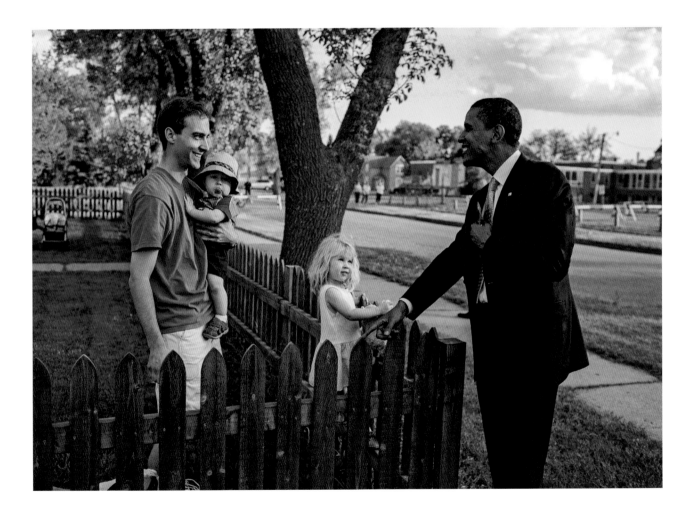

"No matter who you are, what you look like, where you come from, you can make it. That's an essential promise of America. Where you start should not determine where you end up."

—BARACK OBAMA

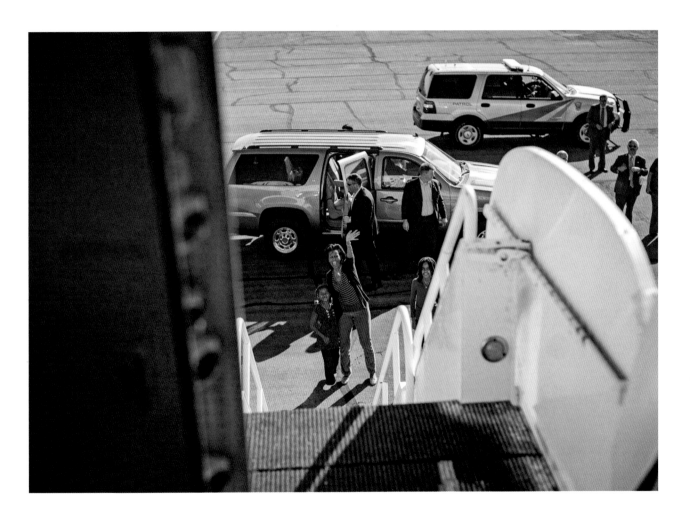

"Every father bears a fundamental obligation to do right by their children."

—BARACK OBAMA

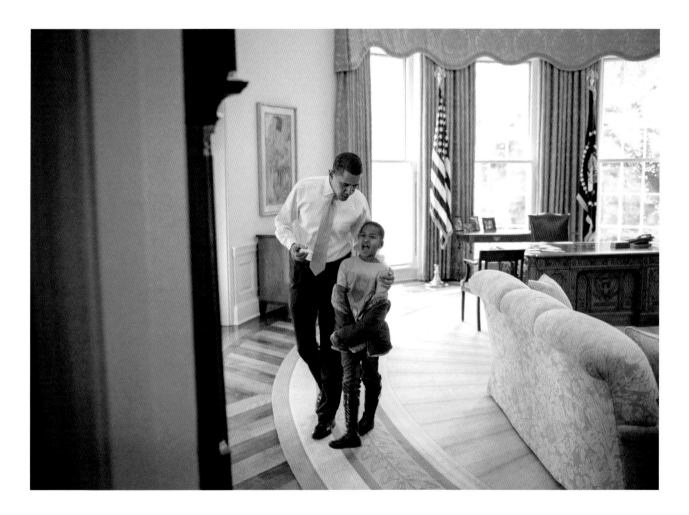

"It's up to us to say to our daughters, don't let the images on television tell you what you are worth, because I want my daughters to dream without limits and reach for those goals. It's up to us to tell our sons, those songs on the radio that glorify violence and glorify materialism, that's not going to cut it in my house. In my house, we live to admire and respect achievement, and self-respect, and hard work, and faith. It's up to us to set those high expectations. And that means meeting those expectations ourselves."

—BARACK OBAMA

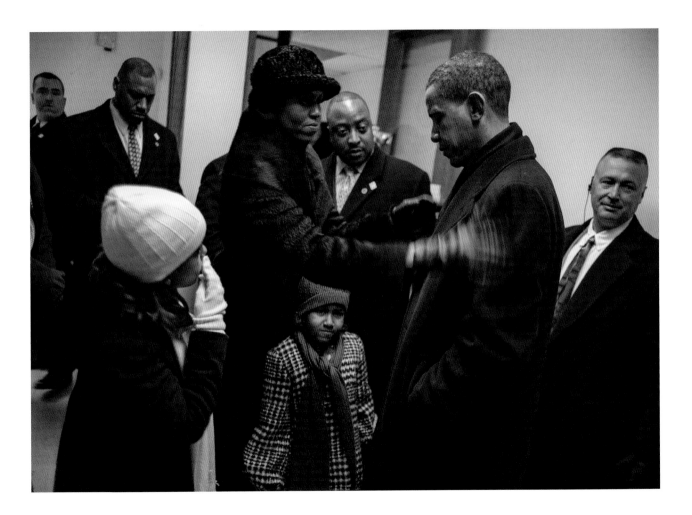

"I didn't just wake up First Lady . . . I mean, I went to law school, I practiced law, I worked for the city, I ran a nonprofit, [and] I was an executive at a hospital. I've been in the world. I've worked in every sector, and you don't do that without coming up against some stuff. You know, having your feelings hurt, having people say things about you that aren't true . . . Life hits you, so over the course of living, you learn how to protect yourself in it. You learn to take in what you need and get rid of the stuff that's clearly not true."

—MICHELLE OBAMA

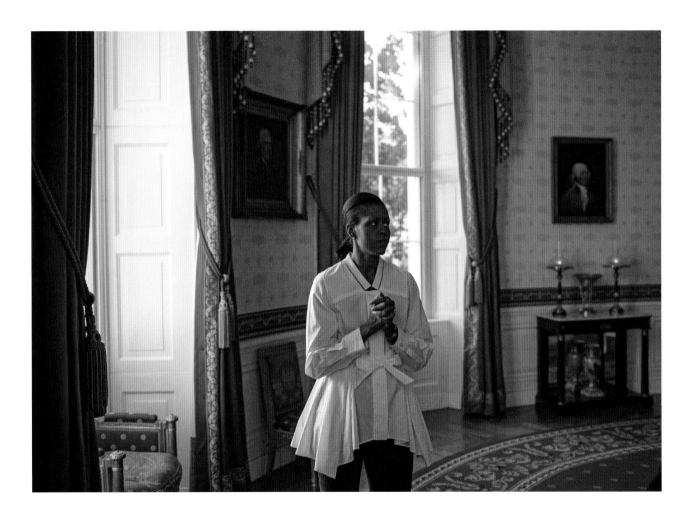

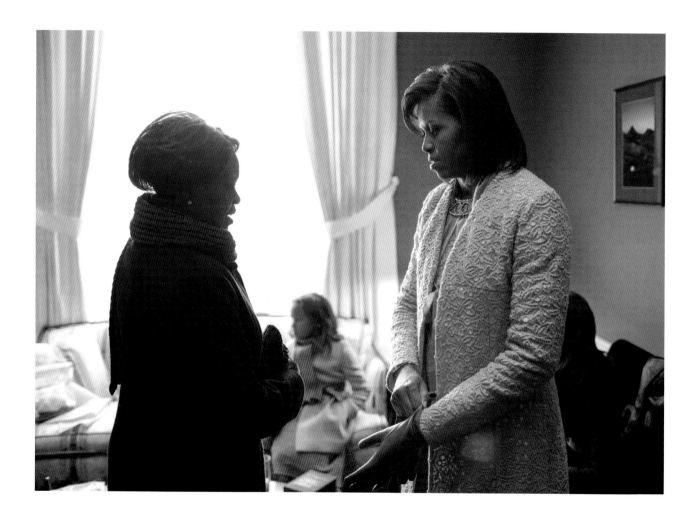

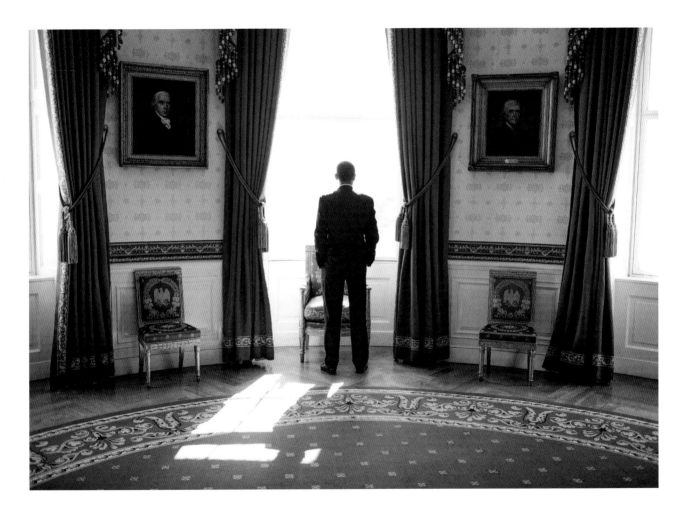

"I don't want us to lose sight that things are getting better. Each successive generation seems to be making progress in changing attitudes when it comes to race. It doesn't mean we're in a post-racial society. It doesn't mean that racism is eliminated. But you know, when I talk to Malia and Sasha, and I listen to their friends and I see them interact, they're better than we are—they're better than we were—on these issues. And that's true in every community that I've visited all across the country."

—BARACK OBAMA

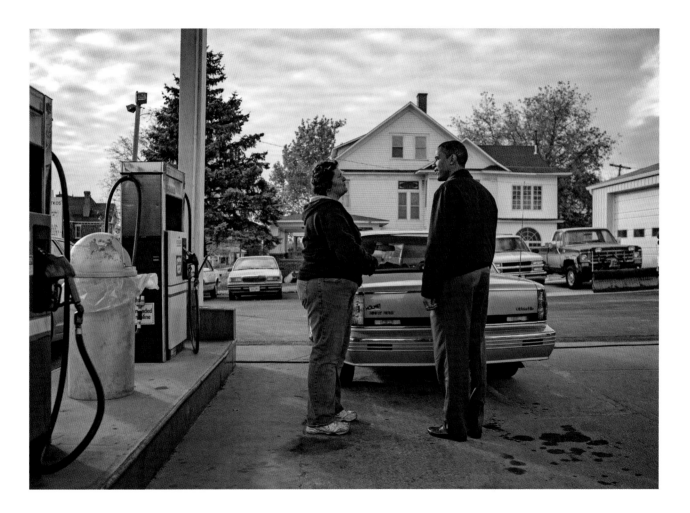

"America isn't Congress. America isn't Washington. America is the striving immigrant who starts a business, or the mom who works two low-wage jobs to give her kid a better life. America is the union leader and the CEO who put aside their differences to make the economy stronger."

—BARACK OBAMA

"With every word we utter, with every action we take, we know our kids are watching us. We as parents are their most important role models."

—MICHELLE OBAMA

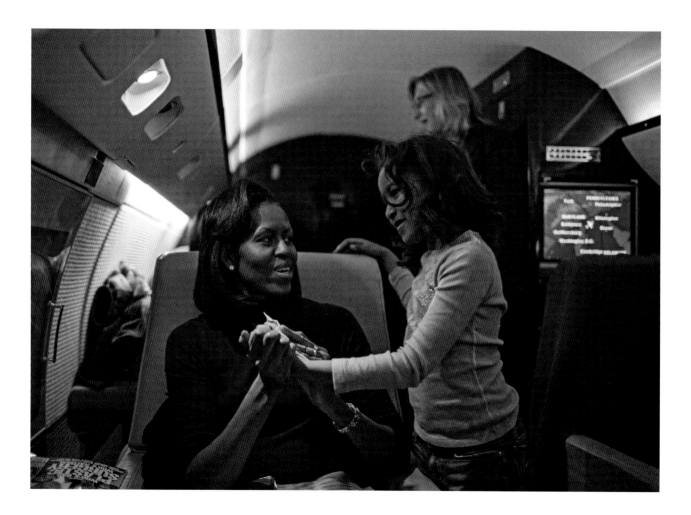

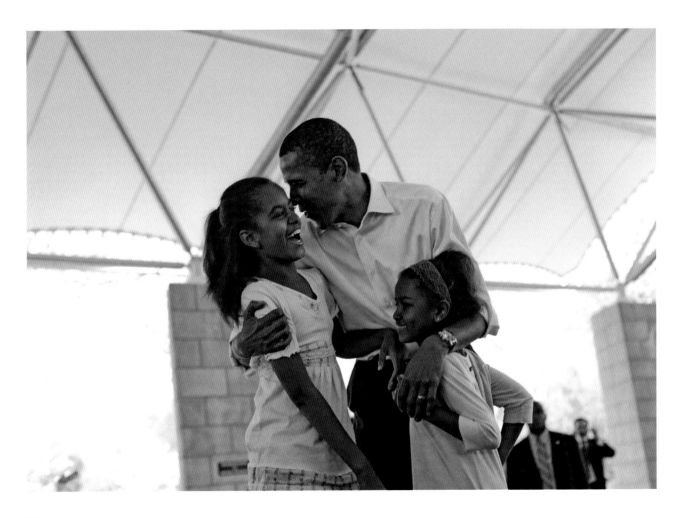

"Let girls learn. Let girls learn so they can help start new ventures and drive economies. Let girls learn so that they can invest in their communities. Let girls learn so they can be safe from violence and abuse. Let girls learn so they can realize their dreams. Because when women have equal futures, families and communities and countries are stronger."

—BARACK OBAMA

"Those who traffic in absolutes when it comes to policy, whether it's on the left or the right, make democracy unworkable. You can't expect to get a hundred percent of what you want all the time. Sometimes you have to compromise. That doesn't mean abandoning your principles, but instead it means holding onto those principles and then having the confidence that they are going to stand up to a serious democratic debate."

—BARACK OBAMA

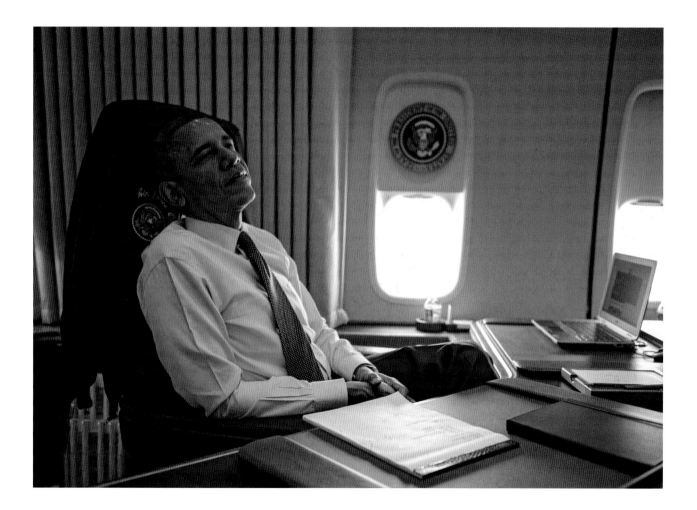

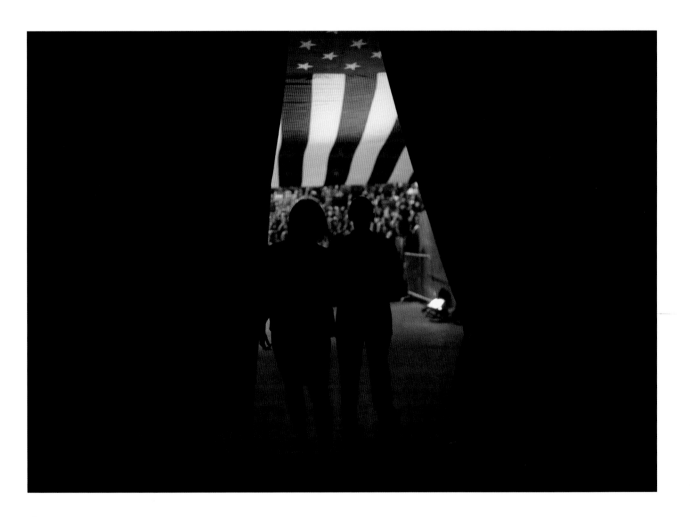

"When you've worked hard and done well and walked through that doorway of opportunity, you do not slam it shut behind you. You reach back and you give other folks the same chances that helped you succeed."

—MICHELLE OBAMA

"We need to reject any politics that targets people because of race or religion. This is not a matter of political correctness. It's a matter of understanding just what it is that makes us strong. The world respects us not just for our arsenal; it respects us for our diversity and our openness and the way we respect every faith."

—BARACK OBAMA

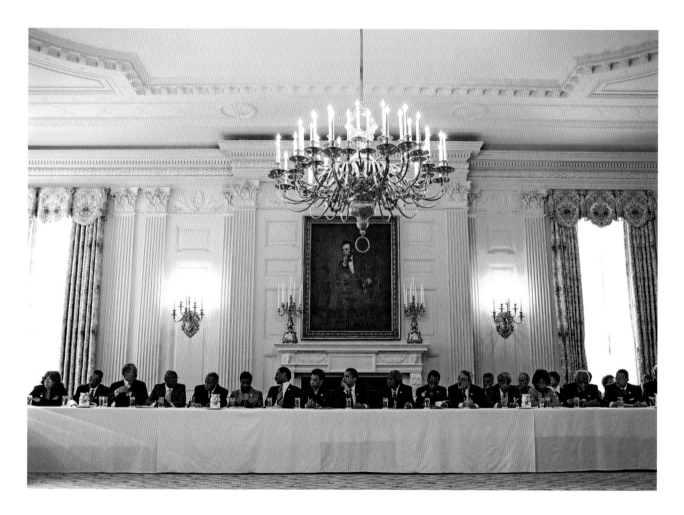

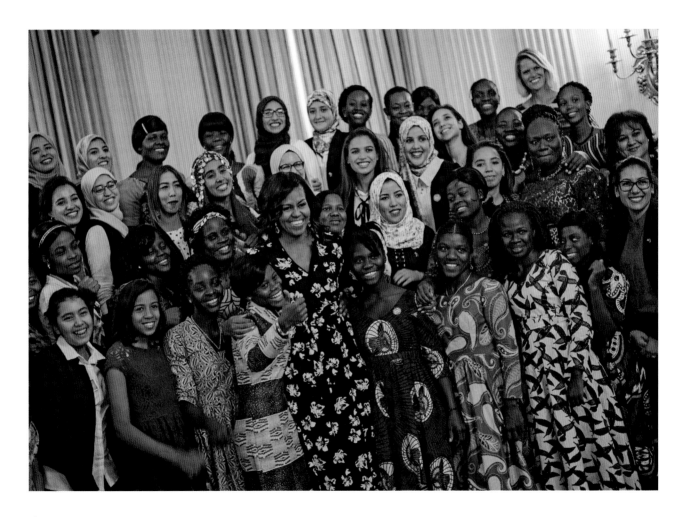

"Our glorious diversity—our diversity of faiths and colors and creeds—that is not a threat to who we are, it makes us who we are."

—MICHELLE OBAMA

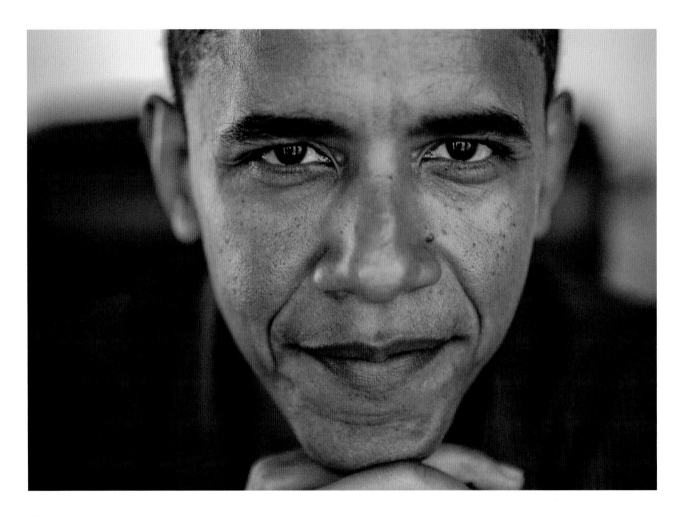

"We're so afraid of each other . . . color . . . wealth, these things that don't really matter still play too much of a role in how we see one another. And it's sad, because the thing that least defines us is the color of our skin."

—MICHELLE OBAMA

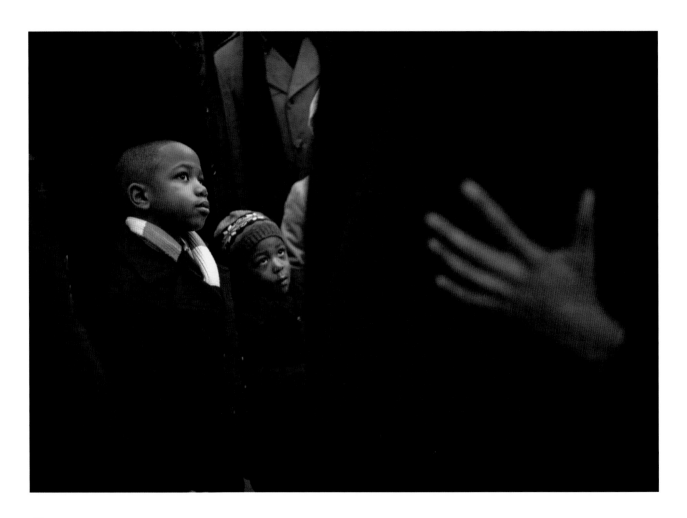

"Nelson Mandela reminds us that no one is born hating another person because of the color of his skin or his background or his religion. People must learn to hate. And if they can learn to hate, they can be taught to love. For love comes more naturally to the human heart. Love comes more naturally to the human heart—let's remember that truth. Let's see it as our North Star. Let's be joyful in our struggle to let that truth manifest on earth so that in a hundred years from now, future generations will look back and say, 'They keep the march going. That's why we live under new banners of freedom.'"

—BARACK OBAMA

"The future rewards those who press on . . . don't have time to feel sorry for myself. I don't have time to complain. I'm going to press on."

—BARACK OBAMA

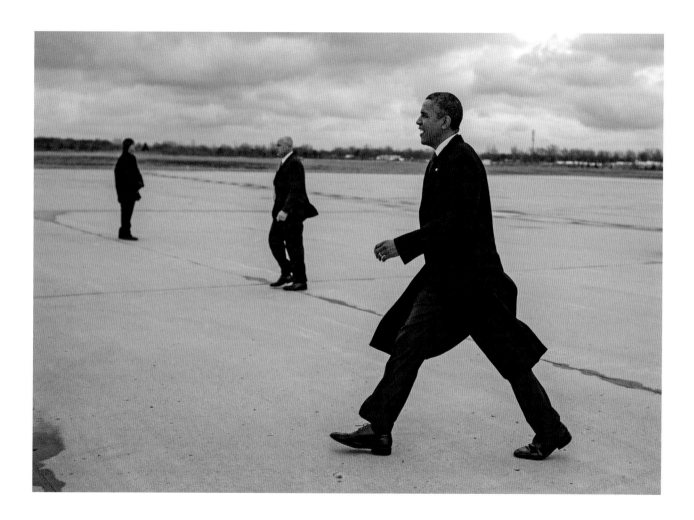

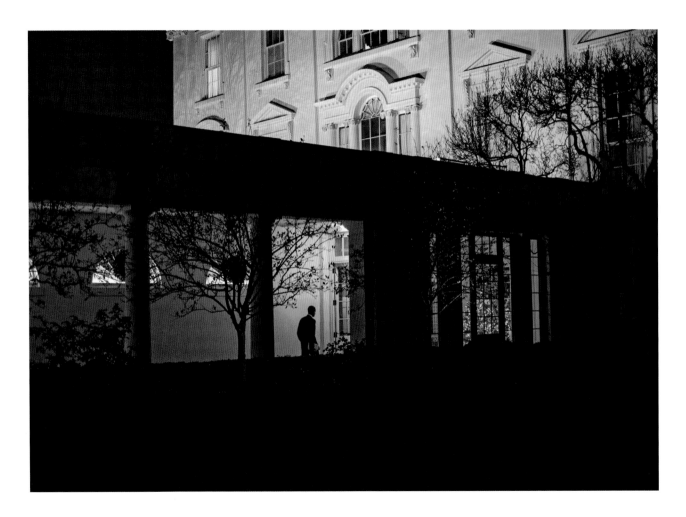

"America's progress has never been smooth or steady. Progress doesn't travel in a straight line. It zigs and zags in fits and starts."

—BARACK OBAMA

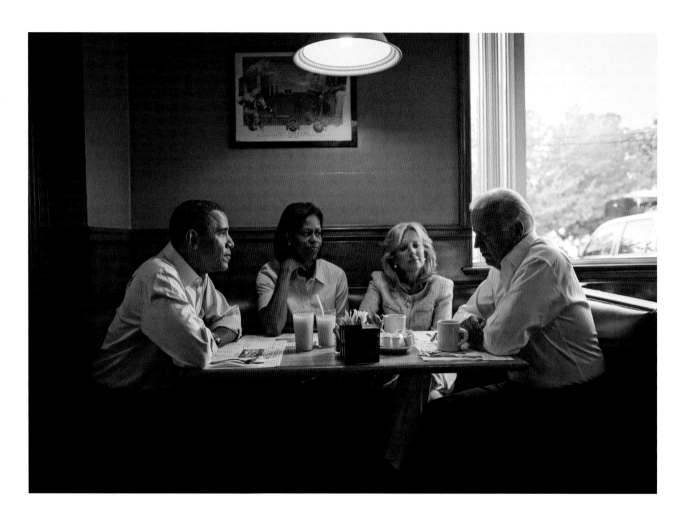

"I've been through this. I've screwed up. I've been in the barrel tumbling down Niagara Falls, and I emerged and I lived. And that's such a liberating feeling. It's one of the benefits of age."

—BARACK OBAMA

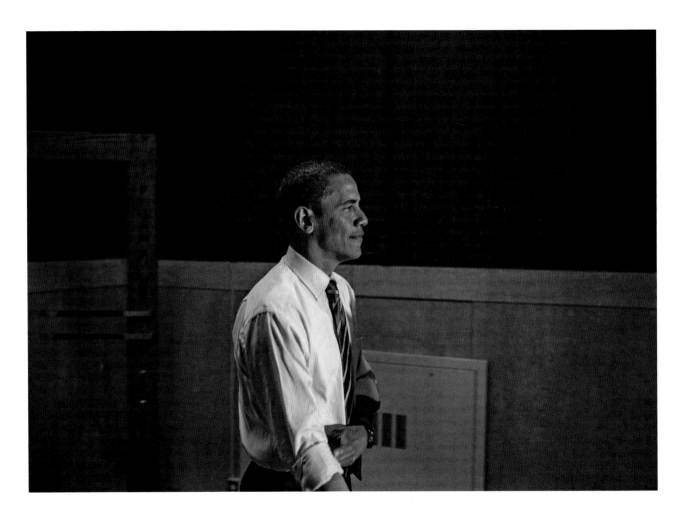

"I've seen first-hand that being president doesn't change who you are. It reveals who you are."

—MICHELLE OBAMA

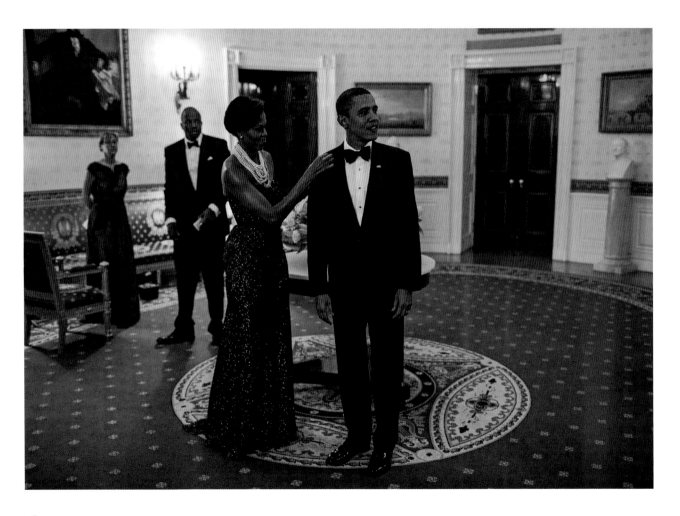

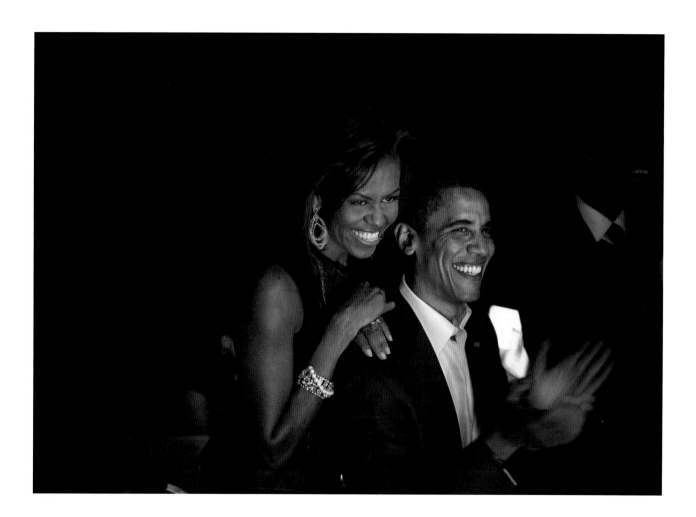

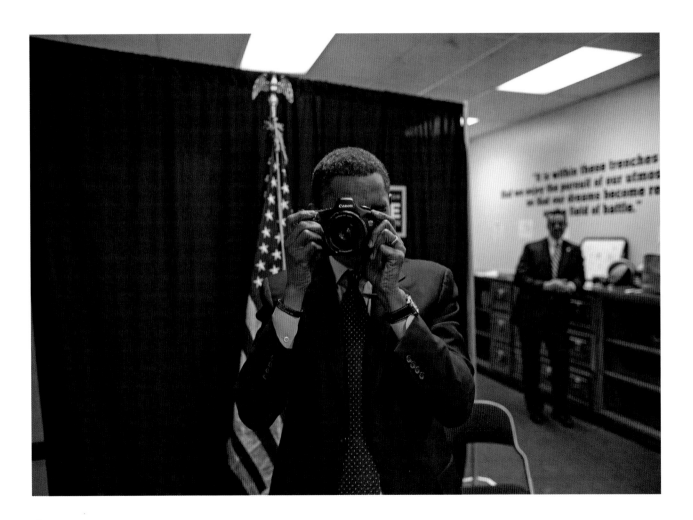

"We have to zealously protect independent media. And we have to guard against the tendency for social media to become purely a platform for spectacle and outrage and disinformation. Let's insist that our schools teach critical thinking to our young people, not just blind obedience."

—BARACK OBAMA

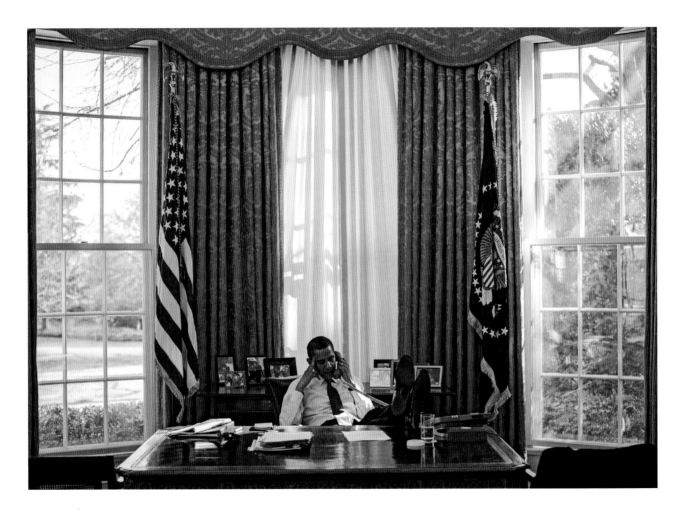

"Life doesn't count for much unless you're willing to do your small part to leave our children—all of our children—a better world."

—BARACK OBAMA

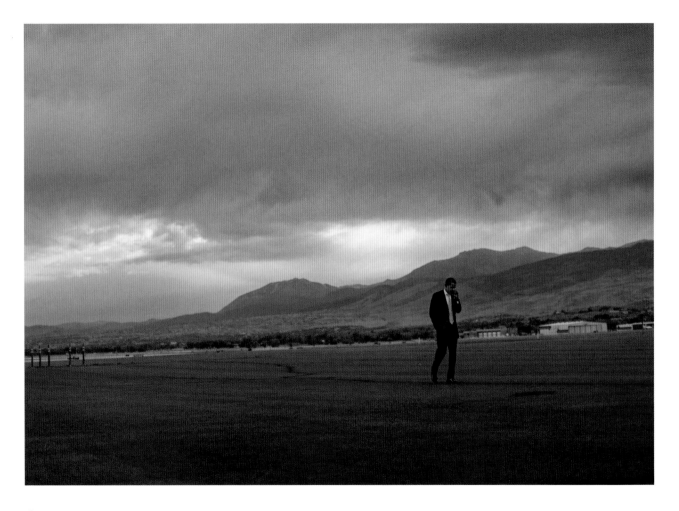

"This is the moment when we must come together to save this planet. Let us resolve that we will not leave our children a world where the oceans rise and famine spreads and terrible storms devastate our lands."

—BARACK OBAMA

"When it comes to the pursuit of justice, we can afford neither complacency nor despair."

—BARACK OBAMA

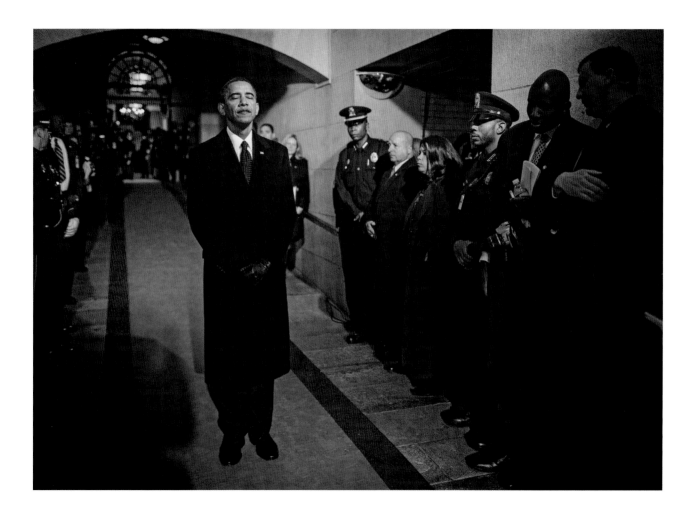

"What could more profoundly vindicate the idea of America, than plain and humble people—the unsung, the downtrodden, the dreamers not of high station, not born to wealth or privilege, not of one religious tradition but many—coming together to shape their country's course?"

—BARACK OBAMA

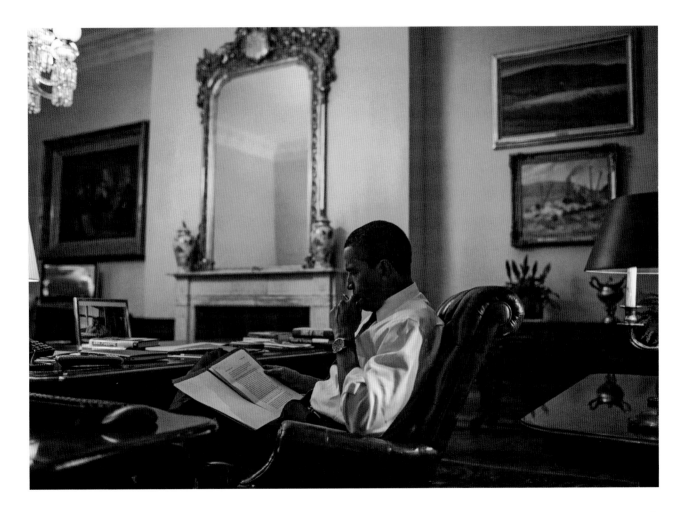

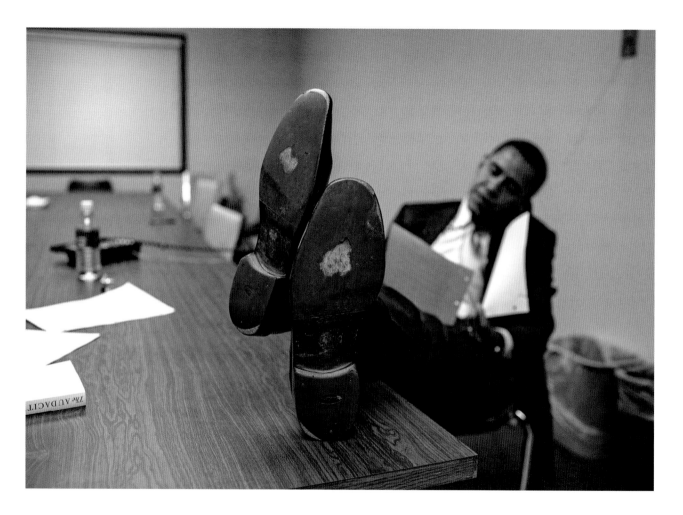

"What I believe unites the people of this nation, regardless of race or region or party, young or old, rich or poor, is the simple, profound belief in opportunity for all—the notion that if you work hard and take responsibility, you can get ahead."

—BARACK OBAMA

"Failure is an important part of your growth and developing resilience. Don't be afraid to fail."

—MICHELLE OBAMA

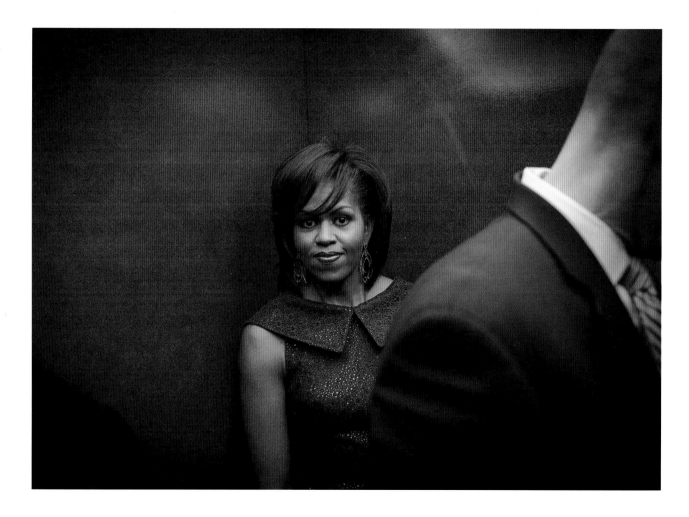

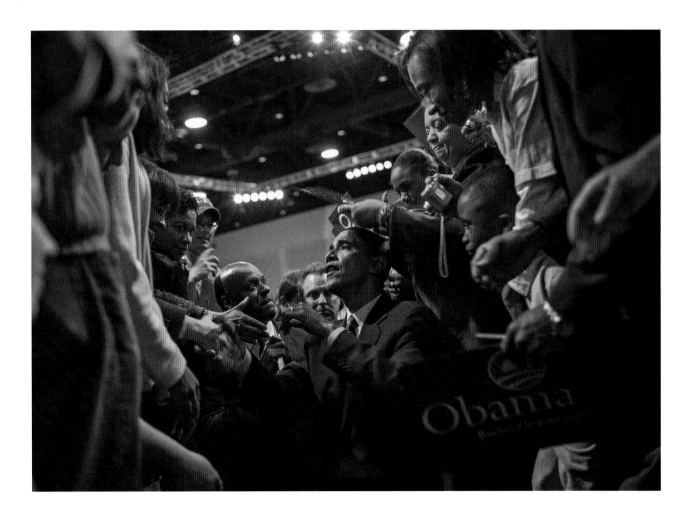

"Even when folks are hitting you over the head, you can't stop marching. Even when they're turning the hoses on you, you can't stop."

—BARACK OBAMA

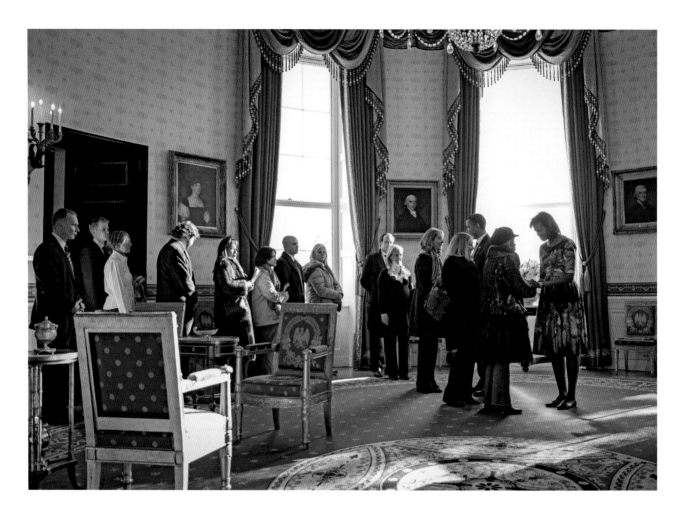

"Democracy depends on strong institutions. It's about minority rights, and checks and balances, and freedom of speech and freedom of expression, and a free press. And the right to protest and petition the government. And an independent judiciary. And everybody having to follow the law. And yes, democracy can be messy and it can be slow and it can be frustrating. I know, I promise. But the efficiency that's offered by an autocrat, that's a false promise, don't take that one because it leads invariably to more consolidation of wealth at the top and power at the top, and it makes it easier to conceal corruption and abuse."

—BARACK OBAMA

"Individually and collectively we can make a difference. We can make things better . . . We have to reject the notion that we're suddenly gripped by forces that we cannot control. We've got to embrace the longer and more optimistic view of history and the part that we play in it."

—BARACK OBAMA

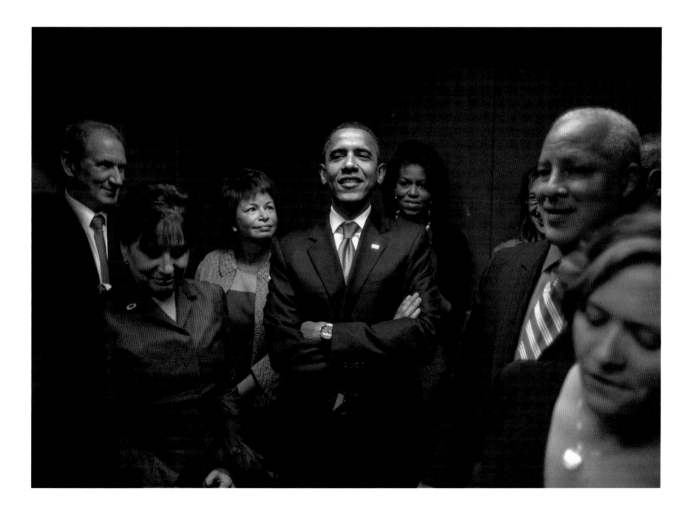

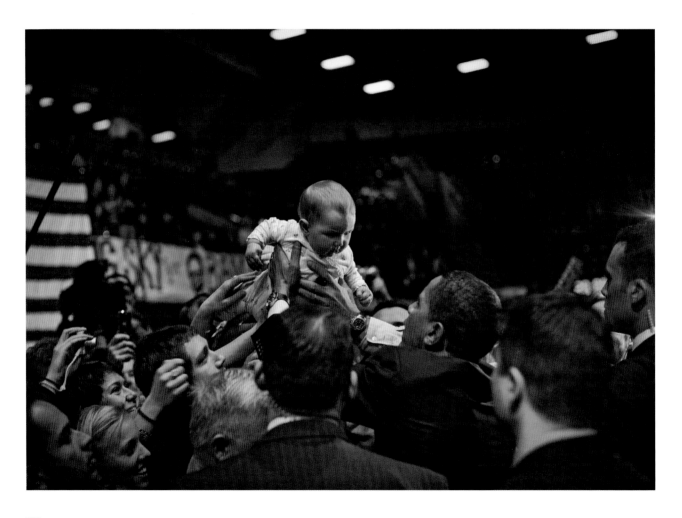

"Hope is that thing inside us that insists, despite all the evidence to the contrary, that something better awaits us if we have the courage to reach for it, and to work for it, and to fight for it."

—BARACK OBAMA

"We have this window of opportunity; we have a chance to make something real happen. Something possible happen, to live beyond our fear—think about that, and help us. Help lift us up, help us fight this fight to change—transform—this country in a fundamental way."

—MICHELLE OBAMA

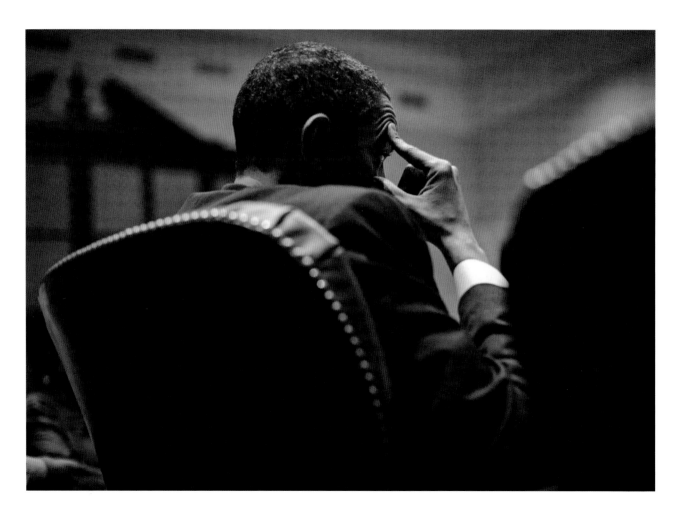

"Today we are engaged in a deadly global struggle with those who would intimidate, torture, and murder people for exercising the most basic freedoms. If we are to win this struggle and spread those freedoms, we must keep our own moral compass pointed in a true direction."

—BARACK OBAMA

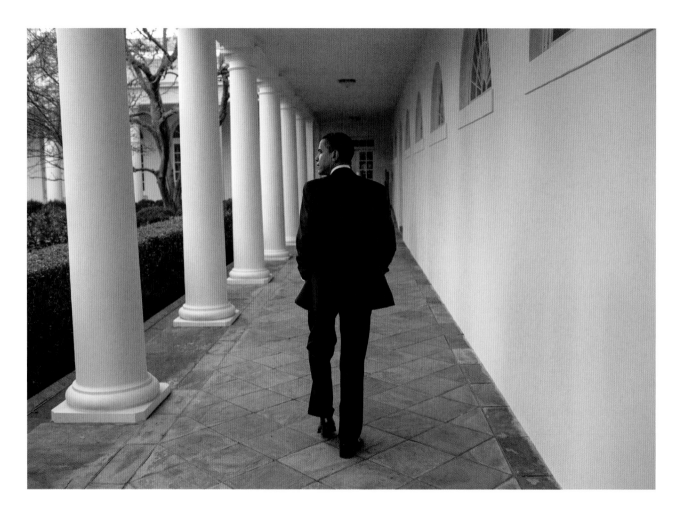

"We choose hope over fear. We see the future not as something out of our control, but as something we can shape for the better through a concerted and collective effort."

—BARACK OBAMA

THE PHOTOGRAPHS

Front cover

Primary morning on a campaign bus outside Derry, NH, January 8, 2008

The first time the Obamas had been alone together in a week. Most meetings during the 2008 campaign consisted of crossover moments in back hallways before rallies.

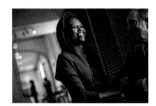

Frontispiece

Cabinet Room, the White House, Washington, DC, March 24, 2009

Obama receives a briefing from Treasury Secretary Tim Geithner on the extent of the U.S. budget crisis and how long it will continue.

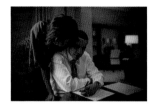

p. 2

Metropolitan Museum of Art, New York City, NY, May 15, 2009

Michelle Obama backstage with NY Mayor Mike Bloomberg for an event supporting art and inner-city schools.

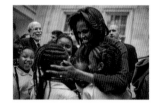

p. 4

Super Tuesday, Hyatt hotel room, Chicago, IL, February 5, 2008

Michelle Obama looks over Obama's remarks to supporters before the Super Tuesday election night rally. In a surprise twist, Obama surpassed Hillary Clinton in delegate numbers.

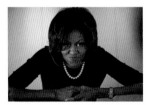

p. 32

Air Force One, Staff Area, April 3, 2009

Michelle Obama talks with staff en route to Europe. It was the Obamas' first foreign trip while in office.

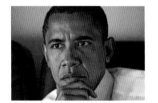

p. 35

En route to Tampa, FL, October 20, 2008

Obama during a briefing. I don't think a person changes in their role as president; instead, I think the office reveals who you are.

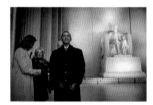

p. 36 and back cover

Lincoln Memorial, Washington, DC, January 18, 2009

President-elect Barack Obama attends, with his family and the Bidens, the "We are One" Inaugural Welcome Concert on the Mall.

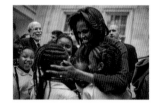

p. 38

The Metropolitan Museum of Art, New York City, NY, May 18, 2009

Michelle Obama greets students from Public School 176 in Queens during an opening of a new wing.

p. 41

Minneapolis, MN,
February 2, 2008

Praying with friends and supporters before a rally.

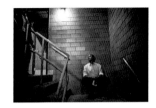

p. 43

Department of Agriculture,
Washington, DC, February 19, 2009

Michelle Obama waits to be introduced and meet workers.

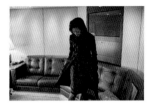

p. 45

Muscatine, IA,
November 7, 2007

Obama listens from a back stairwell as he is introduced. It was his second or third speech of the day.

p. 46

Air Force One, Presidential Office,
Strasbourg, France, April 3, 2009

Michelle Obama shows Obama her outfit before arriving in France to meet French President Sarkozy and wife Carla Bruni.

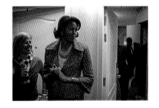

p. 48

Columbia, SC,
January 26, 2008

Michelle Obama waits for Obama outside their hotel room after winning the South Carolina primary. Obama is grabbing his paper on the right.

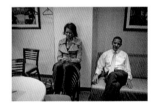

p. 49

Oprah Winfrey Show green room,
Chicago, IL, October 3, 2006

The Obamas relax in the green room before appearing on *The Oprah Winfrey Show*.

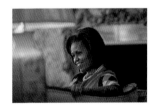

p. 51

Winfield House, London, England,
April 2, 2009

Michelle Obama visits with the wife of the U.S. Chargé d'Affaires.

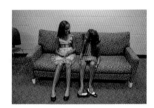

p. 52

Invesco Field, Denver, CO,
August 28, 2008

Sasha and Malia in a holding room after their father accepted the Democratic Party presidential nomination.

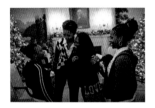

p. 55

Diplomatic Reception Room,
the White House, December 1, 2009

Michelle Obama created several
programs that brought young women
into the White House, including an
internship program that assigned high
school girls a female mentor at the White
House—she was a mentor one year.

p. 56

Pinkas Synagogue, Prague,
Czech Republic, April 5, 2009

Michelle Obama visits the synagogue
where the names of 80,000 Holocaust
victims are inscribed on the wall.

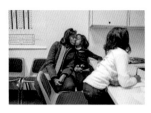

p. 57

JFK Stadium, Washington, DC,
January 19, 2009

"Day of Service" and the day before
the inauguration.

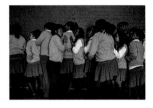

p. 59

Elizabeth Garrett Anderson School,
London, England, April 2, 2009

Choir members listen as one of
their peers performs a solo for Michelle
Obama on the other side of the wall.

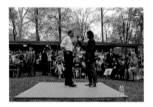

p. 61

Noblesville, IN,
May 3, 2008

Campaigning at a county picnic in the
Forest Park.

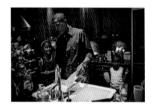

p. 63

Hyde Park, Chicago, IL,
October 2, 2006

Obama and the girls get breakfast and
wash the dishes. This morning he took
the girls to school and Michelle Obama
went to work.

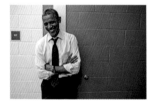

p. 64

Windham High School, Windham, NH,
August 18, 2012

Obama waits in the hallway while he is
introduced at a rally.

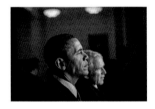

p. 66

United States Capitol, Washington, DC,
January 20, 2009

Obama and George W. Bush prepare to
exit the Capitol where Bush will depart
via helicopter for his farewell flight
out of DC.

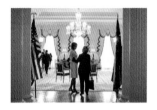

p. 68

Winfield House, London, England, April 1, 2009

Michelle Obama and Secretary of State Hillary Clinton.

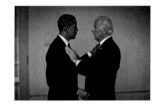

p. 69

Crowne Plaza, Sunrise, FL, October 29, 2008

Obama and Joe Biden in the last days of the campaign. Here they are talking before a series of television interviews together.

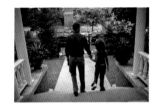

p. 70

Hyde Park, Chicago, IL, October 2, 2006

Departing his home with daughter Malia. Obama was taking both girls to school.

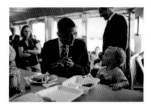

p. 72

Glider Diner, Scranton, PA, April 21, 2008

Obama shares breakfast with young diner Daniel Van Dusky the morning before the Pennsylvania primary.

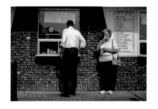

p. 73

The Windmill ice cream shop, Aliquippa, PA, August 29, 2008

Obama orders ice cream at the start of a three-day bus tour of Pennsylvania and Ohio.

p. 75

Campaign bus, Butte, MT, July 4, 2008

Watching television before a campaign rally. They were together to celebrate Malia's tenth birthday.

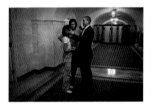

p. 76

Ground Floor, Residence, the White House, Washington, DC, March 17, 2009

The Obamas listen to their daughter Malia talk about her day at school and her first session training their new dog, Bo—who at the time was a secret.

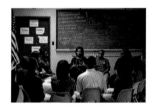

p. 79

Anacostia High School, Washington, DC, March 19, 2009

After the press left, Michelle Obama told students they could ask anything they wanted. One of the first questions was, "Do you do your own makeup and hair?"

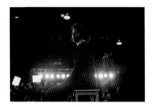

p. 80

University of Illinois, Chicago, IL, February 11, 2007

That morning Obama announced he was running for the 2008 presidency.

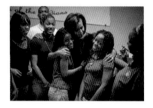

p. 82

Anacostia High School, Washington, DC, March 19, 2009

The students at Anacostia are trying to rise up out of extreme poverty. When we arrived in the motorcade, all the homes near the school were boarded up to protect against shootings.

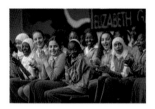

p. 84

Elizabeth Garrett Anderson School, London, England, April 2, 2009

Students react upon seeing Michelle Obama arrive at their school.

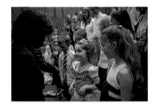

p. 86

Hilton Hotel, Prague, Czech Republic, April 4, 2009

Greeting U.S. Embassy staff and their families.

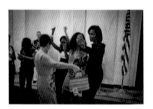

p. 87

Entrance Hall, the White House, Washington, DC, March 19, 2009

Michelle Obama kicks back with Alicia Keys and Keys' mother, Terri Augello Cook, after an event honoring Women's History Month.

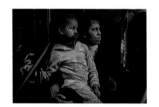

p. 88

Iowa State University, Ames, IA, February 11, 2007

Michelle Obama listens with her younger daughter, Sasha, to Obama during a campaign rally.

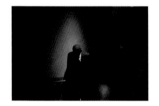

p. 91

Civic Center Coliseum, Roanoke, VA, October 17, 2008

Waiting to take the stage.

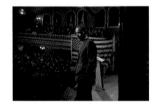

p. 93

Opera House, Rochester, NH, January 7, 2008

Obama takes questions from the audience.

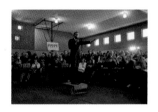

p. 94

Davenport, IA,
January 1, 2008

Obama at a town hall meeting in a community gym. No one could see him, so his staff found a wooden crate and made it into a stage.

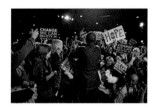

p. 95

World Trade Center, Boston, MA,
February 4, 2008

Obama greets a crowd at a campaign rally.

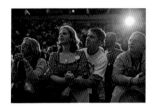

p. 97

Target Center, Minneapolis, MN,
February 2, 2008

A young couple listens to Obama speak at a campaign rally.

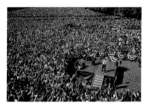

p. 98

Gateway Arch, St. Louis, MO,
October 18, 2008

One hundred thousand people turn out to see Obama at a rally in St. Louis. As he went from underdog to front-runner, crowds of 50,000 to 100,000 people became normal.

p. 99

Denver, CO,
August 28, 2008

All smiles in a sea of confetti after Obama accepted the Democratic Party presidential nomination.

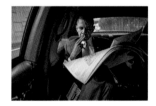

p. 101

Limo en route to the White House,
Washington, DC, January 19, 2010

One year into his presidency. Reading over the morning papers after an education event in Fairfax, Virginia.

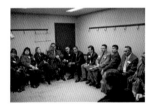

p. 102

Butte, MT,
April 5, 2008

Meeting with local workers.

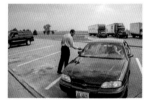

p. 105

Peoria, IL,
October 4, 2006

Obama stops at a rest area on the back roads. There are no secret service agents, no staff, no motorcade or traveling press corps.

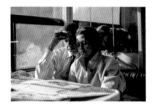

p. 106

Campaign bus outside Derry, NH, January 8, 2008

It was primary morning in New Hampshire. The Obamas had been campaigning separately all week and found a rare moment of quiet together.

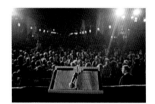

p. 108

Harrisburg, PA, April 19, 2008

Speech after a campaign rally.

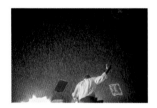

p. 110

University of Mary Washington, Fredericksburg, VA, September 27, 2008

Rain didn't deter him or the crowd as they made their final push toward election day. Obama kept speaking, and no one seemed to care or leave.

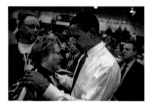

p. 112

Cedar Rapids, IA, February 10, 2007

This mother had lost her son in the war with Iraq. She wanted people to know that it was not unpatriotic to be against the war and still support Obama.

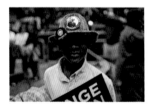

p. 114

Allentown, PA, March 31, 2008

A young man attends a campaign rally for Obama to show his support.

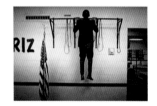

p. 116

Missoula, MT, April 5, 2008

Two staffers had just passed and done two pull-ups. Not to be outdone, Obama did three with ease, dropped, and walked out to make a speech.

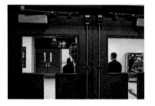

p. 118

Wayne, IN, April 4, 2008

Obama peeks at me from a doorway before a campaign rally.

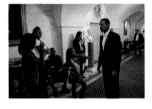

p. 119

Executive Residence, the White House, Washington, DC, January 20, 2009

Malia takes a photograph of her father all dressed up before her parents head to the inaugural balls.

p. 120

**Oval Office, the White House,
Washington, DC, January 28, 2009**

Working late at night on a
budget issue.

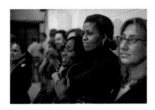

p. 123

**Hoover High School, Des Moines, IA,
January 2, 2008**

Michelle Obama has her arms around
Obama's half-sister Auma Obama
(of Kenya).

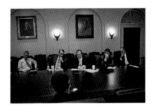

p. 124

**Cabinet Room, the White House,
Washington, DC, March 24, 2009**

White House staff listen to the
president during a briefing for a
national press conference that night.
(Staff L to R: Rahm Emanuel, David
Axelrod, Robert Gibbs, Dan Pfeiffer
and Phil Schiliro.)

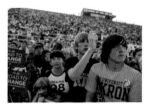

p. 126

**Campaign rally, Dublin, OH,
August 30, 2008**

A large crowd turns out to hear Obama
speak at a campaign rally. He attracted
many first-time voters.

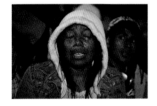

p. 129

**Manassas, VA,
November 3, 2008**

A woman cries while listening to
Obama during his last campaign rally.
His grandmother had passed away
hours earlier, and he gave an emotional
speech about what she meant to him.

p. 130

**Campaign bus, Derry to Salem, NH,
February 6, 2008**

Obama takes a brief nap on the bus in
between late-night rallies. Campaigns
include being away from your family
and a lot of naps on a couch on the bus.

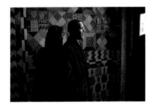

p. 132

**Wilmington, DE,
January 17, 2009**

Waiting to walk out to a rally at the
Amtrak Station. They were kicking off
inauguration week with a train ride to
Washington, DC.

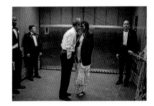

p. 133

**Washington, DC,
January 20, 2009**

For warmth, Obama puts his jacket
around Michelle Obama in a freight
elevator. They were headed to their
fifth of ten inaugural balls.

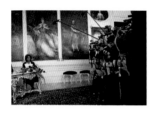

p. 134

Prague Castle, Prague, Czech Republic, April 5, 2009

Michelle Obama looks on at the press during a welcome ceremony with Obama and Czech President Klaus.

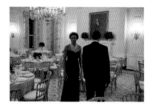

p. 136

State Dining Room, the White House, Washington, DC, February 22, 2009

Before their first formal affair.

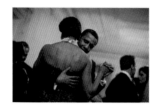

p. 137

East Room, the White House, Washington, DC, February 22, 2009

In a room of 200-plus guests, Obama seems to tune out the world around him when he begins to slow dance with Michelle Obama.

p. 139

Columbia, SC, January 26, 2008

In a hotel room the morning of the South Carolina primary, which they won later.

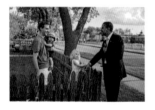

p. 140

Aberdeen, SD, May 31, 2008

It had been a hard day. Obama seemed so happy to be able to go out—alone—for a walk. When he saw this family, he just stopped by for a chat.

p. 142

Airport, Pueblo, CO, November 1, 2008

Michelle Obama, Sasha (7), and Malia (10) greet Obama and his campaign plane three days before the election.

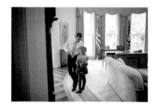

p. 144

Oval Office, the White House, Washington, DC, February 16, 2009

Sasha stops by the Oval Office to say hi to her father during the family's first few months at the White House.

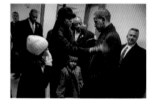

p.146

Old State Capitol, Springfield, IL, February 10, 2007

Malia and Sasha look on as their mother tidies up their father. A few minutes later he stepped out to announce his 2008 run for the presidency.

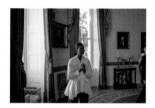

p. 148

**Blue Room, the White House,
Washington, DC, January 24, 2009**

Getting a historical tour of the White House during their first week in office.

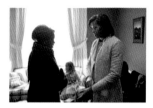

p. 149

**Holding room, United States Capitol,
Washington, DC, January 20, 2009**

Michelle Obama with her mother, Marian Robinson, minutes before walking out for Obama's swearing in as the 44th President of the United States.

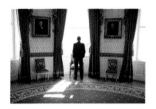

p. 150

**Blue Room, the White House,
Washington, DC, February 23, 2009**

Obama looks out over the South Lawn while waiting for an event to begin. He had said to me: "I feel like I live in a museum."

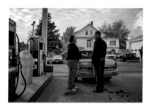

p. 152

**Albia, IA,
November 8, 2007**

Just bought his paper-bag lunch across the street. Stops to talk to a woman at the gas pump.

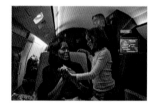

p. 155

**Private plane,
January 16, 2009**

Michelle Obama talks with Sasha as they fly to Philadelphia to meet Obama to kick off the inaugural week.

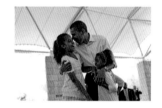

p. 156

**Headwater Park, Fort Wayne, IN,
May 4, 2008**

Obama kids around with daughters Malia and Sasha during a picnic. It is hard to make campaigning fun, but he tried.

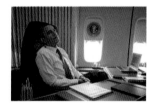

p. 159

**Private office, Air Force One,
December 12, 2012**

Heading to Redford, Michigan.

p. 160

**Evansville, IN,
April 22, 2008**

Entering a rally on the night of the Pennsylvania primary. Obama lost to Clinton.

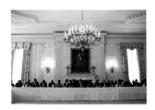

p. 163

State Dining Room, the White House, Washington, DC, February 26, 2009

Obama listens to the U.S. Congressional Black Caucus voice their concerns.

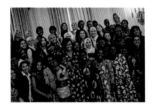

p. 164

State Dining Room, the White House, Washington, DC, October 11, 2016

Photograph with young ladies from Liberia and Morocco.

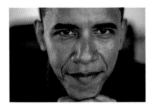

p. 166

Senate Office, Chicago, IL, October 2, 2006

Following an interview with *Time* magazine on the possibility of his run for president in 2008.

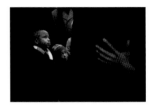

p. 168

State Capitol, Columbia, SC, January 21, 2008

Tre (left) and Caleb Jackson wait as a long line of adults greet Obama before a rally on Martin Luther King Jr. Day. They never took their eyes off of him.

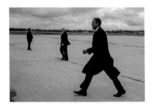

p. 171

Redford, MI, December 10, 2012

Walking to greet a crowd on the tarmac.

p. 172

The Colonnade, the White House, Washington, DC, December 2, 2009

Departing the West Wing after finishing his schedule for the day. Obama heads to see his family in the residence of the White House.

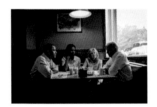

p. 174

Yankee Kitchen Family Restaurant, Boardman, OH, August 30, 2008

The Obamas share breakfast with vice-presidential running mate Joe Biden and his wife, Jill. They were on a bus tour through Ohio.

p. 176

American Legion Mall, Indianapolis, IN, May 5, 2008

Obama waits for musician Stevie Wonder to finish singing before entering a campaign rally.

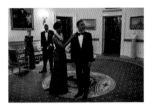

p. 178

**Blue Room, the White House,
Washington, DC, February 22, 2009**

Waiting to greet guests. (Always
dusting him off.)

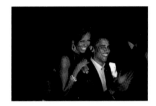

p. 179

**Hammerstein Theater, New York City,
NY, October 16, 2008**

The Obamas listen backstage to a
concert by Bruce Springsteen and
Billy Joel.

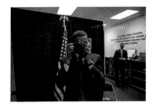

p. 180

**University of Missoula, Missoula,
MT, April 5, 2008**

After a series of press interviews,
Obama borrows one of my cameras to
take my photograph.

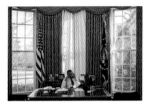

p. 182

**Oval Office, the White House,
Washington, DC, February 23, 2009**

Obama makes congressional calls from
his desk in the Oval Office.

p. 184

**Reno, NV,
September 29, 2008**

During the campaign, Obama was not
one to sit still when he talked on the
phone. Walking the airport tarmac
seemed a way for him to work out
issues in his head.

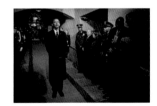

p. 187

**United States Capitol, Washington, DC,
January 20, 2009**

Obama waits in the wings to walk out
and become the 44th President of the
United States.

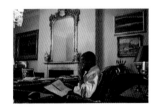

p. 189

**Executive Residence, the White House,
Washington, DC, March 24, 2009**

With his daughters and Michelle
Obama at Camp David, Obama reads
letters from citizens in his private study
late into the evening. All the lights on
the floor were out except in his office.

p. 190

**Providence, RI,
March 1, 2008**

Obama doing press interviews by
phone between events. When he saw
me photographing his shoes, he said
he had already had them resoled once
since he entered the race. They were
his lucky shoes.

p. 193

**Metropolitan Opera House,
New York City, NY, May 18, 2009**

Michelle Obama in an elevator between meeting inner-city school students and visiting the American Ballet Company.

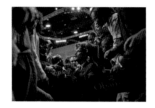

p. 194

**Convention Center, Columbia, SC,
February 16, 2007**

Obama works through a crowd after a campaign rally. It was amazing for a new candidate's rallies to be this large and energetic.

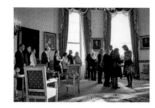

p. 196

**Blue Room, the White House,
Washington, DC, January 21, 2009**

Greeting the public during their first week in office.

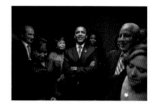

p. 199

**St. Paul, MN,
June 3, 2008**

Riding a freight elevator up to his victory rally the night of the last primary. He had just secured enough votes and delegates to win the Democratic nomination.

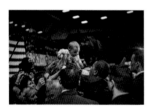

p. 200

**University of Missoula, Missoula, MT,
April 5, 2008**

Obama had been briefed by the Secret Service that people would get so excited they would toss their babies to him. At first he did not believe them.

p. 202

**Winfield House, London, England,
April 2, 2009**

Receiving a briefing before going to an event with young girls in England and then later to meet Queen Elizabeth II for the first time.

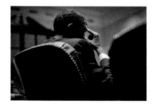

p. 204

**Roosevelt Room, the White House,
Washington, DC, December 2, 2009**

At the end of his first year in office, Obama was still dealing with the United States economy. The pressure to fix everything right away was phenomenal.

p. 206

**Colonnade, the White House,
Washington, DC, January 30, 2009**

Obama walks from his residence to his office in the West Wing of the White House. He had been president for ten days.

Acknowledgments

The images in this book go back to 2004, when I first met Barack Obama. The journey that led to it goes back fifty-eight years, to my birth. I can't possibly thank all the people who have helped me along that path. I can only honor each of you, in my heart, for lifting me up, empowering me, and helping me become who I am. Thank you.

My mother was my best friend and biggest role model. She was a brave and strong mother, teacher, and woman. Although taken from us too early, she gave us more love in those few years than most people get in a lifetime. She believed in me and made me believe in myself. She taught me there is good in everyone, to always treat others as you would like to be treated and, most importantly, that we are all equal on this earth. She showed me that hugs are the best medicine and that all people deserve love and respect. She loved all people unconditionally, as we all should.

My dad taught me that I was born with all I needed to be whoever I wanted, but I had to work to make it happen. I know it was hard raising the three of us after Mom was gone, yet he was able to teach me to leap and fly. I will always be your little girl, Dad, standing on your feet, dancing.

My husband Vince is the most amazing human being I have ever known—the complete and perfect package. Smart, funny, giving, and good-looking. The best spouse, dad, editor, writer, chef, and friend. He has edited my work for twenty-five years, making me a better photographer and a better person. He listened to my fears and pushed me back out there when I didn't want to go, but needed to. He gave, and still gives, not just to me and our son, Hunter, but to everyone he encounters. To all reading this, know that head-over-heels, completely in love with your mate is possible—and essential.

I don't know how Hunter turned out so great. He'll hate me for writing about him—so sorry—but he will always be my proudest achievement and the greatest gift his father and I have ever received. I hope he touches the stars and sees the world as I have. And I hope he knows how terribly I missed him all the times I was gone. Thank you, Hunter, for your love and support for this project, even though it was mostly because you thought Obama was so wonderful.

My siblings are more than my family—they are my village. No one could have been a better big sister than Sloan, who stepped in when Mom was gone and bought me my first photography book. I'm sorry my brother Bob had to grow up so fast and miss so much time with Mom, but our adventures in Korea will always be one of my favorite memories. And though he may be seven inches taller than me, Walker will always be my baby brother. Mary Ruth, another strong, smart and beautiful woman in my life who was taken from us too soon, is also loved and missed.

I am lucky to have the best two uncles a girl could grow up with. Hal was my rock. He looked after me and made me feel smart despite being a skinny, shy kid who stuttered. George was my diplomat, showing me the world through his photographs and implanting the idea that I could see the world with a camera—an idea I ran with.

To the Obamas, I hope my images show you the respect you deserve. Beyond our height and big ears, I think Barack Obama and I connected because of our common beliefs that we married up, had great kids, and were sure nice people did finish first sometimes. Thank you for always asking about Vince and Hunter, even as President when the world demanded so much.

I was in awe of Michelle Obama the moment I met her in her home in Chicago in 2006. Thank you for your graciousness. And thank you Sasha and Malia for the smiles and the hugs. Marian Robinson, you reminded me of my mother—always kind and accepting.

Valarie Jarrett and Melissa Winters have been my supporters and my friends during this entire project. Robert Gibbs allowed me to just hang out and make the images in this book. Pete Souza let me tag along and be his shadow during the first 100 days and more. I will always hold over him the statement, "I am not going to love them like you," which his images disprove. And Lawrence Jackson was a kind soul. Thank you all for your generosity.

The day I turned down the job with the Obamas, I had a radio interview with Michele Norris for National Public Radio. Filled with guilt and doubt, I fell apart. She had the perfect words: "You made the right decision for you and your son. You don't want to watch Malia and Sasha grow up and miss Hunter's life." Thank you, Michele. You were so wise.

A campaign and the presidency require the complete love and dedication of so many. Every image you see in this book is because someone allowed me to do my job. I would like to mention a few, with love and thanks: David Axelrod, Avril Bailey, Bill Burton, Katie Hogan, Kristin Jarvis, Katie Johnson, Denis McDonough, Katie McCormick Lelyveld, Reggie Love, Katie Lillie, Brian Mosteller, Marvin Nicholson, Dan Pfeiffer, Liz Reiter, Ellie Schafer, Tommy Vietor, and Peter Weeks. And for those who thought it was their duty to hinder me, I still love you anyway.

The staff members of the White House Executive Residence are the warmest individuals I have ever worked with, from the ushers to groundskeepers to chefs. They serve not only the President but also their country. They treat the White House, its occupants and visitors as family. A special thanks to Buddy Carter, Christeta

Comerford, Reggie Dickson, George Hannie, Quincy Jackson, James Ramsey, Ray Rogers, Smiley Saint-Aubin and Daniel Shanks.

I'd also like to thank the women and men of the United States Secret Service, who put their lives on the line each day for their country. They came to my aid so many times, not just when I worked at the White House, but during the twenty years that followed. Thank you for vouching for me when asked by a principal or staff member. I feel so honored to have stood by so many of you, even if my feet still hurt from it. Joe Clancy, Yvonne Dicristoforo, Holly Fraumer, Dave Holmes, Danny Spriggs, and Jeff Gilbert—please know how deep my respect goes for all of you.

I would never have gotten past my college newspaper job if not for Veita Jo Hampton. She introduced me to the world of photojournalism. Her love and knowledge changed my life. My first job out of college was with the *Tennessean* newspaper in Nashville, where the photographers, photo editors, and writers took me under their wings. Thank you, Ray Wong, for giving me a chance, and Nancy Rhoda, who will always be my most respected mentor. She and Pat Casey Daley paved the way for so many women photographers. Dwight Lewis taught me how important a person's soul is to their work. And I was fortunate to have the late John Seigenthaler as my first editor in chief and ethical touchstone. He taught me that freedom of the press is essential to a fair and just democracy, and that it is our responsibility to expose injustices, right wrongs and be a voice for those without one. My fellow photographers, editors and writers at the *Tennessean*, *Nashville Banner* and *Pittsburgh Press* provided the best schools ever.

My foray into government and politicians was through the Clinton-Gore administration. I know Marla Romash only hired me for my wonderful husband, but thank you. Dennis Alpert: you made work an adventure—I love you for that. Al and Tipper Gore displayed a respect for our government and country I had never encountered. They worked then and now for a better world. Tipper gave me the best advice when I started: "No one knows what you do, so make it what you want. Own it." I also want to thank Stephanie Beard, Phil Humnicky, Bob McNeely, and Janet Phillips for all their support.

After the White House, *Time* magazine convinced me I would have the adventure of a lifetime covering politics, which I did. Strong women who edited my work and made me look good surrounded me. Thank you MaryAnne Golon, Alice Gabriner, Michelle Stephenson, Leslie Dela Vega, and Hillary Raskin. Diana Walker was my inspiration and queen of the decisive moment. And thanks, too, to the *Time* writers I have worked with. Rick Stengel at *Time* supported my coverage of the Obamas. This book would not exist without him.

Geoff Blackwell and Ruth Hobday, my book editors and publishers, believed in my work and made this book happen. They have also been incredibly supportive and wonderful to Vince and me. Thanks, too, to Cameron Gibb and the rest of the Blackwell & Ruth team and family for all their hard work and research; Kathy Best has been a family friend for over twenty years. She also happens to be a great editor. Thank you, Kathy, for editing my rambling thoughts; Freddy Paxton and Steve Kaufman are my family and DC home away from home. Thank you for feeding and housing me, and for your friendship to Vince, Hunter, and me; Anna McCollister-Slipp, the best doctor, saved me during the 2009 Inauguration.

Lastly, I'd like to acknowledge my colleagues in the press corps. They are an amazing group of people, who sacrifice time from their families to dedicate their lives to revealing truths. In this day and time, they deserve more than ever our respect and gratitude.

First published in the United States of America in 2019 by Chronicle Books LLC.

Produced and originated by Blackwell and Ruth Limited
Suite 405, IronBank, 150 Karangahape Road, Auckland 1010, New Zealand
www.blackwellandruth.com

Publisher: Geoff Blackwell
Editor in Chief: Ruth Hobday
Design Director: Cameron Gibb
Designer & Production Coordinator: Olivia van Velthooven
Publishing Manager: Nikki Addison
Additional editorial: Mike Wagg, David Carles

Library of Congress Cataloging-in-Publication Data available.

ISBN 978-1-4521-8280-3

Chronicle Books LLC
680 Second Street
San Francisco, CA 94107
www.chroniclebooks.com

10 9 8 7 6 5 4 3 2 1

Every effort has been made to trace the copyright holders and the publisher apologizes for any unintentional omission. We would be pleased to hear from any not acknowledged here and undertake to make all reasonable efforts to include the appropriate acknowledgment in any subsequent editions.

Sources for quoted material: p. 33, 39, 89, 107, 128, 165, Reach Higher & Counselor of the Year Event, The White House, Washington, DC, USA, January 6, 2017; p. 34, 37, 103–4, 113, 158, 169, 181, 197, Nelson Mandela Annual Lecture, Johannesburg, South Africa, July 17, 2018; p. 40, 81, 154, Democratic National Convention, Philadelphia, Pennsylvania, USA, July 27, 2016; p. 42, Democratic National Convention, Denver, Colorado, USA, August 25, 2008; p. 44, "President Obama & Marilynne Robinson: A Conversation—II", *The New Yorker*, November 19, 2015; p. 47, Elizabeth Garrett Anderson School, London, UK, April 2, 2009; p. 50, International Women of Courage Awards, U.S Department of State, Washington, DC, USA, March 11, 2009; p. 53, 58, 60, 62, 117, "This Is What a Feminist Looks Like", *Glamour* magazine, August 4, 2016; p. 54, Summit of the Mandela Washington Fellowship for Young African Leaders, Washington, DC,

USA, July 30, 2014; p. 65, United States of Women Summit, Washington, DC, USA, June 14, 2016; p. 67, 90, 115, 138, 161, 177, Democratic National Convention, Charlotte, North Carolina, USA, September 4, 2012; p. 71, 74, 145, Father's Day Remarks at the Apostolic Church of God, Chicago, Illinois, USA, June 15, 2008; p. 77, "Barack Obama: 'We Need Fathers to Step Up'"— copyright © Barack Obama, PARADE, June 16, 2011; p. 78. Senior Recognition Night, Topeka West High School, Kansas, USA, May 22, 2014, p. 83, Oxford University, Oxford, UK, May 25, 2011, p. 85, Campaign Rally, UCLA, Los Angeles, California, USA, February 3, 2008, p. 92, Young African Women Leaders Forum, Regina Mundi Church, Soweto, South Africa, June 22, 2011, p. 96, 109, Anacostia Senior High School Commencement, Washington, DC, USA, June 11, 2010, p. 100, Interview with Bill O'Reilly, the White House, Washington, DC, USA, February 2, 2014, p. 111, Democratic race election-night speech, Chicago, Illinois, USA, Feb 5, 2008, p. 121, Commencement Address, University of Michigan, Ann Arbor, Michigan, USA, May 1, 2010, p. 122, 135, 147, 167, Interview with Oprah Winfrey, the White House, Washington, DC, USA, December 19, 2016; p. 125, 127, 131, 186, 188, The 50th Anniversary of Selma to Montgomery Marches, Selma, AL, USA, March 7, 2015; p. 141, College Opportunity Summit, Ronald Reagan Building, Washington, DC, USA, December 4, 2014; p. 143, Presidential Proclamation, Father's Day, June 15, 2012; p. 151, Remarks on Trayvon Martin, The White House, Washington, DC, July 19, 2013; p. 153, Congressional Hispanic Caucus Institute's 37th Annual Awards Gala, Washington, DC, USA, October 2, 2014; p. 157, White House Development Day, White House Summit on Global Development, Washington, DC, USA, July 20, 2016; p. 162, State of the Union Address, United States House of Representatives, Washington, DC, USA, January 13, 2016; p. 170, 195, Congressional Black Caucus Foundation Phoenix Awards Dinner, Washington, DC, USA, September 24, 2011; p. 173, Commencement Address, Rutgers, Brunswick, New Jersey, USA, May 15, 2016; p. 175, Episode 613 of the *WTF* podcast with Marc Maron, June 22, 2015; p. 183, Father's Day speech, Chicago, IL, June 15, 2008; p. 185, Foreign Policy Speech, Berlin, Germany, July 24, 2008; p. 191, State of the Union Address, United States House of Representatives, Washington, DC, USA, January 28, 2014; p. 192, "The Power of an Educated Girl" panel, New York City, New York, USA, September 29, 2015; p. 198, Goalkeepers 2017 Event, New York City, NY, USA, September 20, 2017; p. 201, Caucus Speech, Des Moines, Iowa, USA, January 3, 2008; p. 203, Campaign rally, Des Moines, Iowa, USA, August 16, 2007; p. 205, Floor Statement on the Nomination of Alberto Gonzales for Attorney General, Washington, DC, USA, February 3, 2005; p. 207, United Nations General Assembly, New York City, New York, USA, September 24, 2014. All other text copyright © 2019 Callie Shell.

Printed and bound in China by 1010 Printing Ltd.

This book is made with FSC®-certified paper and other controlled material and is printed with soy vegetable inks. The Forest Stewardship Council® (FSC®) is a global, not-for-profit organization dedicated to the promotion of responsible forest management worldwide to meet the social, ecological, and economic rights and needs of the present generation without compromising those of future generations.